FATHER HIDALGO
ARCHIVES

FATHER HIDALGO
ARCHIVES

Like Father Like Grand Son

AVE..HID..ALL...GO

iUniverse, Inc.
Bloomington

FATHER HIDALGO ARCHIVES
LIKE FATHER LIKE GRAND SON

iUniverse books may be ordered through booksellers or by contacting:

iUniverse
1663 Liberty Drive
Bloomington, IN 47403
www.iuniverse.com
1-800-Authors (1-800-288-4677)

Because of the dynamic nature of the Internet, any web addresses or links contained in this book may have changed since publication and may no longer be valid. The views expressed in this work are solely those of the author and do not necessarily reflect the views of the publisher, and the publisher hereby disclaims any responsibility for them.

Any people depicted in stock imagery provided by Thinkstock are models, and such images are being used for illustrative purposes only.
Certain stock imagery © Thinkstock.

ISBN: 978-1-4502-8897-2 (sc)
ISBN: 978-1-4502-8898-9 (ebk)

Printed in the United States of America

iUniverse rev. date: 06/25/2012

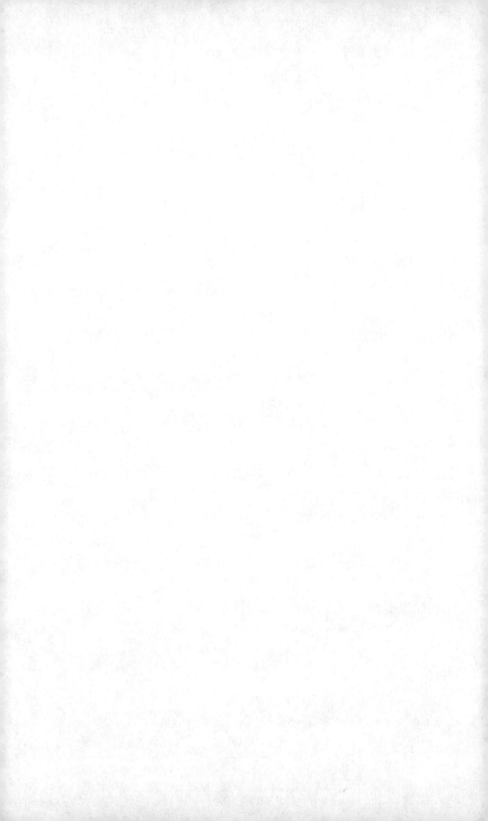

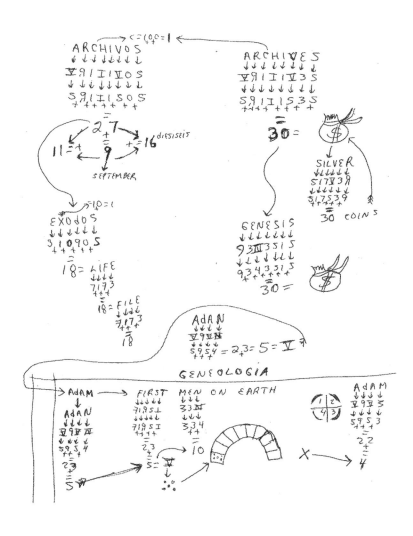

SIGN OF THE CROSS

BIGINING
↓↓↓↓↓↓↓↓
I3I9IⅢIⅨ9
↓↓↓↓↓↓↓
I3I9I4I49
+++++++
$\overline{\overline{33}}$ → ✝✝✝

MESSAGE
↓↓↓↓↓↓↓
3355Ⅴ93
↓↓↓↓↓↓↓
3355593
+++++++
$\overline{\overline{33}}$ → ✝✝✝

→ ∪=∩=⊃=C=I00=I
 ++
SUMARIAN
↓↓↓↓↓↓↓↓
5I3Ⅴ9IⅤⅣ
↓↓↓↓↓↓↓↓
5I359I54
++++++++
$\overline{\overline{33}}$ → ✝✝✝

PAPIRO ——→ PAPEL
↓↓↓↓↓↓ ↓↓↓↓↓
9ⅤⅣⅠ9O 9Ⅴ937
↓↓↓↓↓↓ ↓↓↓↓
959I9O 95937
++++++ ++++
$\overline{\overline{33}}$ → ✝✝✝ $\overline{\overline{33}}$ → ✝✝✝

bAbEL
↓↓↓↓↓
9Ⅴ937
↓↓↓↓
95937
++++
$\overline{\overline{33}}$ →

GOSPEL
↓↓↓↓↓↓
905937
✝✝✝ +++++ ✝✝✝
$\overline{\overline{33}}$ → ✝✝✝

•••••••••••••
↑TENOSHTITLAN
↓↓↓↓↓↓↓↓↓↓↓↓
I3ⅢO5II II7ⅤⅣ
↓↓↓↓↓↓↓↓↓↓↓↓
I340 5II II754
++++++++++++
$\overline{\overline{33}}$ → ✝✝✝

STONEHENGE
↓↓↓↓↓↓↓↓↓
5IOⅢ3I3Ⅳ93
↓↓↓↓↓↓↓↓↓
5IO43I3493
+++++++++
$\overline{\overline{33}}$ → ✝✝✝

NASARETH
↓↓↓↓↓↓↓
ⅣⅤ5Ⅴ93II
↓↓↓↓↓↓↓↓
4555593II
++++++++
$\overline{\overline{33}}$ → ✝✝

dAbId
↓↓↓↓↓
9Ⅴ919
↓↓↓↓↓
95919
++++
$\overline{\overline{33}}$ → ✝✝✝

↗ C=I00=I
 ++
CALVARIO
↓↓↓↓↓↓↓↓
IⅤ7ⅤⅤ9IO
↓↓↓↓↓↓↓↓
I5755.9IO
++++++++
$\overline{\overline{33}}$ → ✝✝✝

↗ C=I00=I
 ++
CHRISTIANOS
↓↓↓↓↓↓↓↓↓↓↓
II9I5IIⅤⅣO5
↓↓↓↓↓↓↓↓↓↓↓
II9I5II5405
+++++++++++
$\overline{\overline{33}}$ → ✝✝✝

ESPAÑOL
↓↓↓↓↓↓↓
359ⅤⅣO7
↓↓↓↓↓↓↓
3595407
+++++++
$\overline{\overline{33}}$ → ✝✝✝

↗ C=I00=I
 ++
CRISTOBAL
↓↓↓↓↓↓↓↓↓
I9I5↓OI3Ⅳ7
↓↓↓↓↓↓↓↓↓
9I9I5IOI357
+++++++++
$\overline{\overline{33}}$ → ✝✝✝

↗ C=I00=I
 ++
COLON
↓↓↓↓↓
IO70Ⅳ
↓↓↓↓↓
IO704
+++++
$\overline{\frac{I2}{3}}$ → SHIPS

2

1810 SEPTEMBER 16 ⟷ 1811 JULY 30

C=10.0=1 U=C=∩=C=10.0=1
GUANAJUATO ⟵ ⟶ CHIHUAHUA
↓↓↓↓ ↓↓↓↓↓ ↓↓↓↓↓↓↓↓
9IⅤⅣⅪ II Ⅴ↓0 I I I I Ⅴ I I Ⅴ
↓↓↓↓ ↓↓↓↓↓ ↓↓ ↓↓↓ ↓↓↓
9,IS45I I SI0 IⅠI I I SII S
+↓+++ ++++ + + + + + + +

3 2̿ = HIdALGO 1̿7 SHIPS OUT OF
↓↓↓↓↓↓↓↓ CAdIS ESPAÑA
I 19Ⅴ790 ↓↓↓↓↓
↓↓↓↓ ↓↓↓ IⅤ9iS
I 195790 ↓↓↓↓↓
+ ++++ 45,9,IS
 + ++
3,2̿ 2̿,1
+
5̿↘ 3̿ SHIPS OUT FROM
 PUERTO dE PALOS

C=10.0=1
↑
CARLOS Ⅴ
↓↓ ↓↓↓↓
IⅤ9705
↓↓ ↓↓↓
15,9705
++ +++

11=↙ 2,7̿ ↘+ 1,6 SIXTEEN
 ↙ 9̿ 7̿ ⟶ FERNANdO
 ↓ ↓↓↓↓↓↓↓↓
SEPTEMBER 73,9Ⅳ ⅤⅣ90
 ↓↓↓↓ ↓↓↓
ABRAHAM 73,945490
↓↓↓↓↓ ↓↓ ++++ +++
Ⅴ13ⅨⅪⅣ 3 4Ⅰ = 5 = HIdALGO
↓↓↓↓↓↓↓ ↓↓ ↓↓ ↓↓
S,39,SI,S,3 I 19Ⅴ790
+++++++ ↓↓↓↓ ↓↓↓
3̿2 I 195790
 ++ ++++
 3̿2

Hidalgo

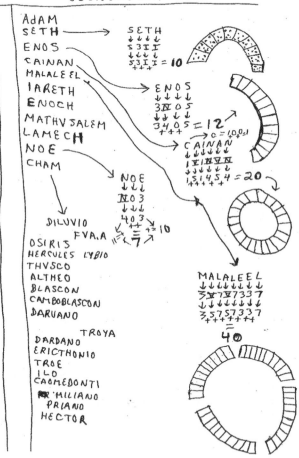

AdAM
SETH ——————> SETH
ENOS ↓ ↓ ↓ ↓
CAINAN 5 3 I I
MALALEEL ↓ ↓ ↓ ↓
IARETH 5 3 I I = 10
ENOCH + + +
MATHVSALEM
LAMECH ENOS
NOE ↓ ↓ ↓ ↓
CHAM 3 ℳ O 5
 ↓ ↓ ↓ ↓
 3 4 O 5 = 12
 + + +
 ——→ O = 10,0,1
 CAINAN
 ↓ ↓ ↓ ↓
 I ℳ ℳ ℳ
 ↓ ↓ ↓ ↓
 1 5 1 4 5 4 = 20

 NOE
 ↓ ↓ ↓
 ℳ O 3
 ↓ ↓ ↓
DILUVIO 4 O 3 = 10
 FVA.A + + + = 7

OSIRIS
HERCULES LYBIO
THVSCO
ALTHEO MALALEEL
BLASCON ↓ ↓ ↓ ↓ ↓ ↓ ↓
CAMBOBLASCON 3 ℳ 7 ℳ 7 3 3 7
DARUANO ↓ ↓ ↓ ↓ ↓ ↓ ↓
 3 5 7 5 7 3 3 7
 TROYA + + + + + +
DARDANO =
ERICTHONIO 40
TROE
ILO
CAOMEDONTI
 ℳILIANO
 PRIANO
HECTOR

4

SCYTHIA (SYRYA)

HELEO O HELENO
ZEVZER
FRANCO
ESORON
ZELIO
BASSABELIANO
PLASERIO
PLESRON
ELIACOR
ZABERIANO

PLASERIO
ANTENOR
PRIAMO
HELENO
PLESRON
BASSABELIANO
ALIXANDREE
PRIAMO
GETILANOR
ALMADION
DILVGLO
HELENO
PLASERIO
DILUGLO
PRIAMO
HILENO
ANTENOR
MARCOMIRO

ALEMANA
GEGNOLOGIA

ANTENOR

SICAMBRO
PRIAMO
HELENO
DIOCLES
BAESANO EL MAGNO
CLODOMIRO
NICANOR
MARCOMIRO
CLUDIO
ANTENOR
CLODOMIRO
MIRODACO
CAVCAMORE
ANTARIO
FRANCO

FRANCO,
MARCOMIRO
CLODOMIRO
ANTENOR
RICHIMERO
ODEMARO
MARCOMIRO

GENEOLOGÍA

FRANCO, DE FRANCIA

CLODOMIRO
FAROBERTO
GVNON
HILDERICO
BALTERO
CLODIO
VVALTERO
DAGOALATO
DAGOBERTO

 PAULO EMYLIO

GENEBALdo
DAGOBERTO
CLODION
MARCOMIRO
FARAMVNDO
CLODION
MEXOVEO

 FRANCIA

CHILDERICO
CLODOVEO
CLOTARIO O LOT.HARIO
WGIBERTO
CHILDEBERTO
THEUDOBERTO
SIGEBERTO

ALEMANA
DVQVES DE

OTTOPERTO EL
GRAVE

THEOBERTO
BABO EL
GRATO
ROTERIO EL
IVSTO
AMPAINTO,

CONTRAMO EL
FORTISSIMO
LVTHARdo EL
RELIGIOJO
VVERNER EL
LIBERAL

RAPOTO
BERENGARIO
OTHON EL
PAVDENTE

VERNERO
ALBERTO EL
RICO
ALBERTO

GENEOLOGIA

ERNESTO
FREDERICO
MAXIMILIANO

SVCCES|SION|

DE CARLOS
↓↓↓↓↓↓
1ᴧ月705
↓↓↓↓↓↓
1 5 9 70 5
+ + + + +

FERNANDO ↓ FERNANDO ↓

II = + ← 2,7 → +=16=7
 + =
 9

(SEPTIEMBRE) QUINTO = V (DIECISEIS)

HidAL6O
↓↓↓↓↓↓↓
I19ᴧ790
↓↓↓↓↓↓↓
I,19579,0
++++ ++
3,2= ⋙POR MEXICO

HIdAL6O ESTA PRESENTE
QUIEREN OTRO PRESIDENTE VERDU6O
O QUIEREN UN REY JUSTO
AN6EL DE INDEPENDENCIA Hidalgo

7

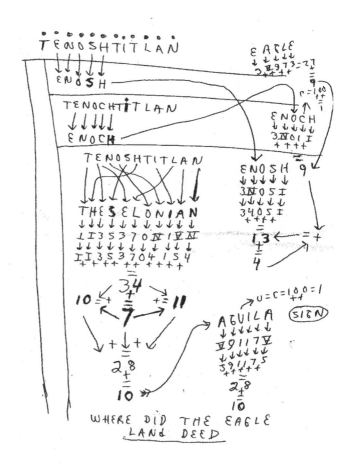

WHERE DID THE EAGLE
LAND DEED

MI BANDERA

AGUILA → c=100=1
↓↓↓↓↓↓
V9117V
↓↓↓↓↓↓
59117 5
+ + + + + +
28
+
10 DIES MANDAMIENTOS
↓

FLAG
↓↓↓↓
77V9
↓↓↓↓
7759
+ + +
28
+
10 MANDAMIENTOS

ALLENDE JIMENES ALDAMA
↓↓↓↓↓↓ ↓↓↓↓↓↓ ↓↓↓↓↓↓
V773V93 133V35 V79V 3 V
↓↓↓↓↓↓ ↓↓↓↓↓↓ ↓↓↓↓↓↓
5773493 133435 57953 5
+ + + + + + + + + + + + + + + + +
38 19 34
+ + +
11 ≫ + →10 ≫ + →7= 28=10

Hidalgo.

9

GEONOLOGIA TERAH

HARET LAND

INGLA TERAH
↓↓↓↓↓ ↓ ↓ ↓↓
I 囮975 I 3 9 囮 I
↓↓↓↓↓ ↓ ↓ ↓↓
I 4975 I 3 9 5 I
+++++ +++++

* 4=1,3 ↓↙+ ↙4↓5 +=14= S
 = c=100=1
 9 ++

HARET SON OF CHAM
EL GRANDE ↓↓↓↓
 1 I 囮 3
 ↓↓↓↓
 4 I S 3
 ===
 10

AdAM AdAN
↓↓↓↓ ↓↓↓
囮9囮3 GRAND SON 囮9囮囮
↓↓↓↓ OF NOAH ↓↓↓↓
5 9 5 3 5 9 5 4
=== 囮 O囮I +++
2 2 ↓↓↓↓ 2 3
= 40 J + ===
4 === S=
 10

X

10

GENEOLOGÍA

dARDANO → HIJO dE CASHI, (SOMETHING)
REY dE ITALIA

ROMA HIJO dEL (?) (AdAME Y ?

dARDANO
↓↓ ↓↓ ↓↓ ↓
9Ⅱ99ⅨⅪ0
↓↓↓↓↓↓↓
95995 40
++++++
4̳1 = 5 = Ⅴ7
+

ITALIA
↓↓ ↓↓↓ ↓
1ⅬⅤ71Ⅴ
↓↓�ↆↆↆↆ
1Ⅰ571 5
++++↓↓
20 →

ROMA
↓↓ ↓↓
903Ⅴ
↓↓ ↓↓
9035 = 17 = 8
+++

LUNA
↓↓↓↓
7Ⅰ̳Ⅳ̳Ⅴ̳
↓↓↓↓
7,14 5
+++
=
17

MUN
↓↓↓
31Ⅳ
↓↓↓
314
+++
7̳+
+ →8 = 25 ↑

AdAME
↓↓ ↓↓ ↓
Ⅴ9Ⅵ 33
↓↓↓ ↓↓
59 5 33
++++ +
2 5 =
=̳ =̳ 7
9 7
+ +

MOON
↓↓↓
300Ⅺ
↓↓↓
3004
+++
=
7

SOL
↓↓↓
507
++
12

19
=
10

GREEKOSPANGLISHROMANOARAB
FROM THE
GREKOLATINEHEBRECHINDUH

ROMANOSALEMANA

WRAP IN LININ

NASARETH ——— ESPAÑOL
↓↓ ↓↓ ↓↓ ↓↓ ↓↓ ↓↓ ↓↓↓
ⅡⅤ 5Ⅺ9 3⊥Ŧ 3 5 9ⅤⅡ 0 7
↓↓ ↓↓ ↓↓↓↓ ↓↓ ↓↓↓ ↓↓↓
4 5 5 5 9 3 Ŧ Ŧ 3 5 9ⅤⅡ 0 7
+ + + + ' + + + + + + + + +
 $\overline{\overline{3}}3$ ⟶ +++ $\overline{\overline{3}}3$

 TANTO MONTA MONTA TANTO
 S U M A R I A N ➤ C=100=1
 ↓ ↓ ↓ ↓ ↓↓↓↓ ++=1
 S I ·3ⅤAⅠⅤⅡ
 ↓ ↓↓ ↓↓ ↓↓↓↓
 S I 3 5 9 I 5 4
 + + + + ' + + +

 $\overline{\overline{3}}3$ ⟶ +++

 E N G L I S H
 ↓ ↓ ↓ ↗ ↘↘↘↘↘↘↘
 E Z B A N G L I S H

JOHN NOAH BLAH IN GLESS
↓↓ ↘↘ ↘↓ ↓↓↓↓ ↓↓ ↙↙↙↙
YO NO HABLAH INGLESS
CON(FUSION) THE LAWS LAND, WAS,
CONFUSION DE LAS LENGWAS

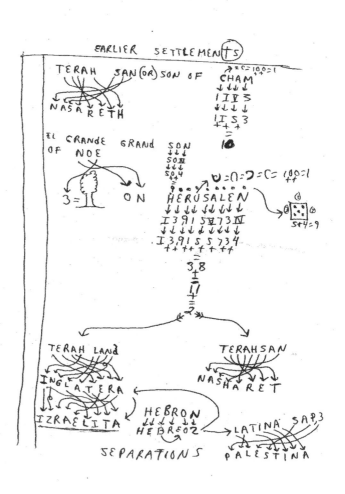

TERAH SAN (OR) SON OF CHAM
NASARETH

EL GRANDE GRAND SON
OF NOE

3 = ON

HERUSALEN

TERAH LAND

INGLATERA

IZRAELITA

TERAHSAN

NASHARET

HEBRON
HEBREOZ

LATINA SAP.3

PALESTINA

SEPARATIONS

14

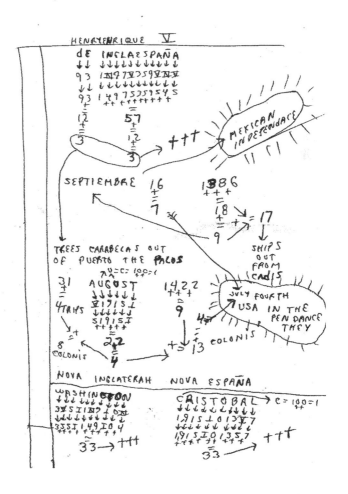

NOVA

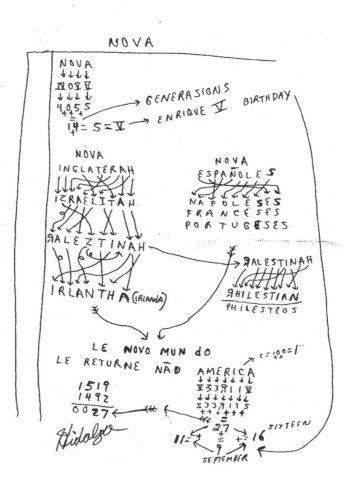

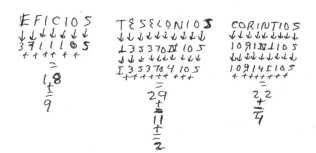

EFICIOS

TESELONIOS

CORINTIOS

FROM THE PAGES OF THE BIBLE
LETTERS OF PAUL TO THE CORINT 105
TO THE EFICIOS AND TESELONIOS
TO THE RIGTH TO THE LEFT BACK AND
FOURTH CUT AND TURN, SWORD WORDS

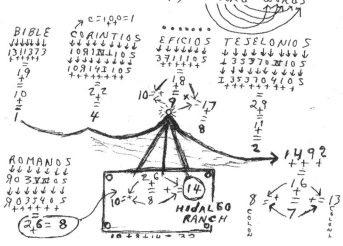

BIBLE CORINTIOS EFICIOS TESELONIOS

ROMANOS

HIDALGO RANCH

THE MORISH 3

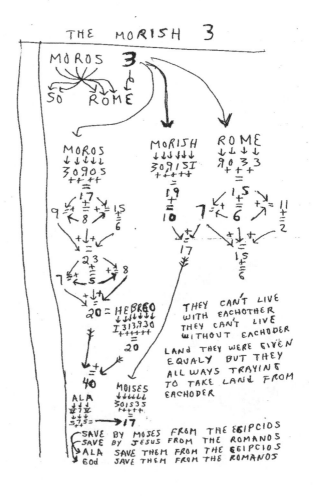

MOROS **3**

50 ROME

MOROS
↓↓↓↓↓
3 0 9 0 5
+ + + +
=
17
9 ← +/=/+ → 15
8
+ ↓ +
=
23
7 +/=/+ 8
5
+ ↓ +
=
20 = HEBREO
↓↓↓↓↓↓
I 3 13 9 30
+++++++
=
20

40

ALA
↓↓↓↓
#7 ¥
↓↓↓
5,7,5 = → 17

MORISH
↓↓↓↓↓
3 0 9 15 I
+ + + +
=
19
=
10

17

MOISES
↓↓↓↓↓
3 0 15 35
+ + + +
=
17

ROME
↓ ↓ ↓ ↓
9 0 3 3
+ +
=
15
7 +/=/+ → 6 +/=/+ → 11
2
+ ↓ +
=
15
6

THEY CAN'T LIVE
WITH EACHOTHER
THEY CAN'T LIVE
WITHOUT EACHODER

LAND THEY WERE GIVEN
EQUALY BUT THEY
ALL WAYS TRAYING
TO TAKE LAND FROM
EACHODER

SAVE BY MOSES FROM THE EGIPCIOS
SAVE BY JESUS FROM THE ROMANOS
ALA SAVE THEM FROM THE EGIPCIOS
God SAVE THEM FROM THE ROMANOS

WRAATH

ALA = MOISES

ANGEL

PURE
I WAS
BORN
WITH
NO SIN
IN TO
A WORLD
OF SIN

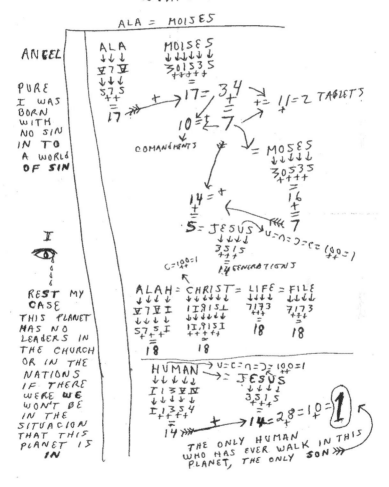

ALA MOISES
↓↓↓ ↓↓↓↓↓↓
♈7♈ 301535
↓↓↓ ++++++
575 =
= 17=→ 34
17 ⇒⇒ + →17= 3,4 += 11=2 TABLETS
 10=⫧=7
 COMANDMENTS = MOSES
 ↓↓↓↓
 30535
 ++++
 =
 14=+ 16
 + +
 5= JESUS ⪡ U=∩=⊃=⊂=(100=)
 ↓↓↓↓ ++
 3515
 +++
 C=100=1 14 GENERATIONS
 ++

ALAH= CHRIST= LIFE = FILE
↓↓↓ ↓↓↓↓↓ ↓↓↓ ↓↓↓
♈7♈I II915⊥ 7173 7173
↓↓↓ ↓↓↓↓↓↓ =
575I II915I 18 18
+++ ++++++
= =
18 18

I
👁
↓
↓
↓
↓

REST MY
CASE
THIS PLANET
HAS NO
LEADERS IN
THE CHURCH
OR IN THE
NATIONS
IF THERE
WERE WE
WON'T BE
IN THE
SITUACION
THAT THIS
PLANET IS
IN

HUMAN U=C=∩=⊃ 100=1
↓↓↓↓↓ ⇒ = JESUS
I13♈Ⅳ ↓↓↓↓
↓↓↓↓ 3515
I1354 +++
++++++
=
14 ⇛⇛ + →14=28=10= ① ↰

THE ONLY HUMAN
WHO HAS EVER WALK IN THIS
PLANET, THE ONLY SON ⇛⇛

NAN WUA SUN TSU

PRO BEAR VIOS (PROVERVIOS)
NAN WUA (PERRO QUE LADRA)
 KNOW MUERTHE
IN TREE MASSA BARK AS MEN KNOWS
SAP PRI ATE, AS

500 B.C

SHU WU

mn SHU PI SHU

SHINA PERU

SUN TSU

SHU WU

CHAM SHUM

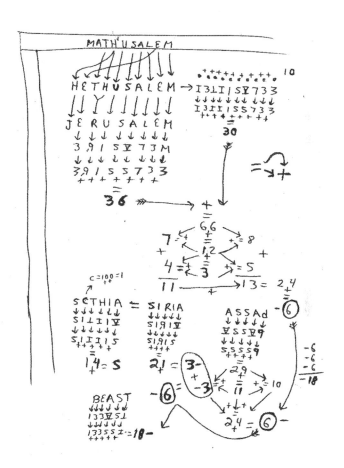

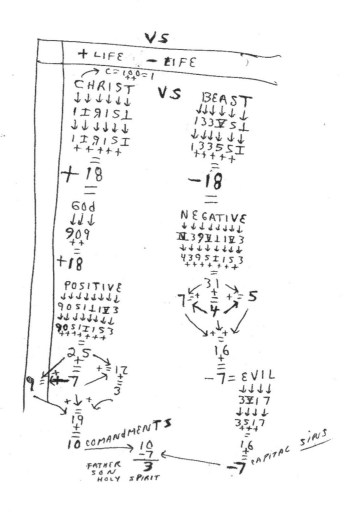

SOME SAID THAT THE HEART IS YOUR
TREASURE. WHATS IN YOUR HEART?
OR SOME SAID THAT TREASURE IS WHERE
THE HEART **IS,** WHATS IN YOUR CHEST?

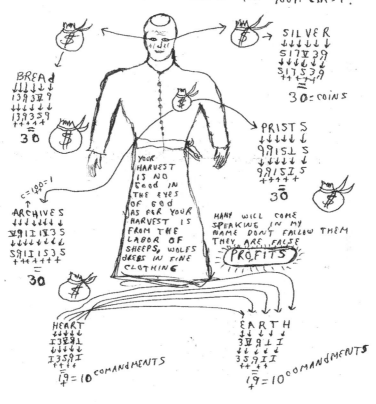

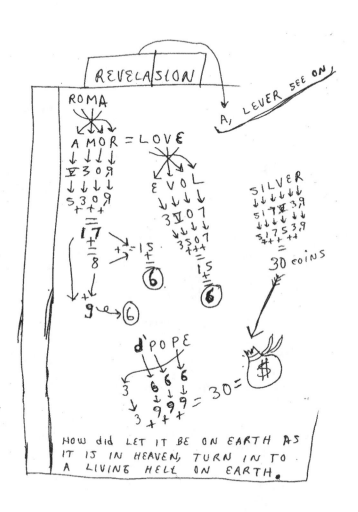

REVELASION

A, LEVER SEE ON

ROMA

AMOR = LOVE

SILVER

30 coins

d'POPE

$

HOW did LET IT BE ON EARTH AS
IT IS IN HEAVEN, TURN IN TO
A LIVING HELL ON EARTH.

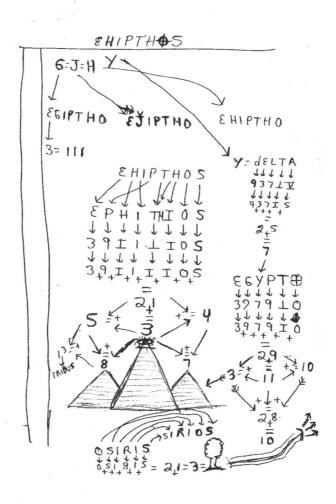

ƐHIPTHOS

25

SPANGLISH

LAST TEAM MADE MEXICA KNOWS
LOSS LOW boss LOSS MI RVN
COME CORd tHE ROWS ILL LOSS
BLOW TONE KNEES SELL LOSST
RAGVN COME OLL LAWS PAL
LOW MASS bE BEEN SEEN
ES PEAR ANSA IS SEEN FEE
UH YEN THE AH KEY PAY YAY
THE AH YAP PACKA

LASTIMA DE MEXICANOS LOS LOBOS
LOS MIRAN COMO CORDEROS Y LOS
GLOTONES SE LOS TRAGAN COMO LAS
PALOMAS VIVEEN SIN ESPERANSA. Y
SIN FE HUYEN dE AQUI PAYA Y DE
AYA PACA.

EN BOLITA Y BIEN ARMAdOS SE CREEN
MUY VALIENTES, Y HOY SE ENCUENTRAN
DESCANSANDO BOCA ARRIVA EN LOS
PANTEONES, CREO QUE LE FALTAN
OYOS A LA TIERRA PARA ENTERRAR
TANTA MUERTE, DE ESTO QUE HOY
LES ESTA SUCEDIENDO.
CUANDO APRENDERAN A VIVIR COMO
dIOS MANDA,
Hidalgo

26

QUIEREN SEGUIR CELEBRANDO UNA INDEPENDENCIA QUE NUNCA AN TENIDO POR OTROS 200 AÑOS, QUIEREN INJUSTICIAS Y DESHIGUALDAD COMO ASTA AHORA LOS AN TENIDO, CUANDO RECAPACITEN Y DECIDAN LO QUE QUIEREN ME AVISAN, SU INDEPENDECIA YO SE LAS DOY CUANDO QUIERAN CON AQUELLA CAMPANA QUE SONARA AQUEL 16 DE SEPTIEMBRE EN AQUEL PUEBLO DE DOLORES POR AQUEL BUEN PADRE QUE SU VIDA DIERA POR LA PATRIA, ESTA PATRIA NUESTRA, QUE HOY EN DOLORES GIME Y LLORA, CUANDO QUIERAN MEXICANOS, CUANDO QUIERAN, QUIERAN, O NO, ALGUN DIA ME BUSCARAN, PARA QUE CURE TODOS SUS DOLORES, SE DESPIDE DE USTEDES CORDIALMENTE,

Hidalgo

QUIEREN SAVER MI NOMBRE PREGUNTENLE A MI MADRE

MOdER (MOTHER)

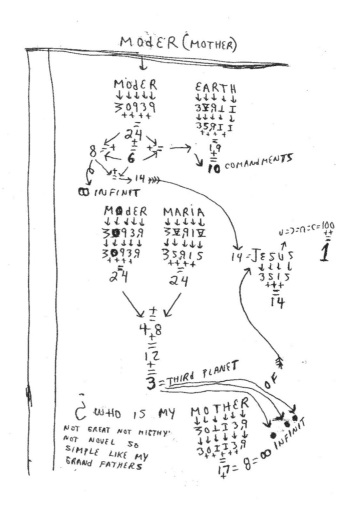

MOdER EARTH

8 + 6 → 10 COMANdMENTS

∞ INFINIT 14

MOdER MARIA

14 = JESUS

4 + 8 = 12 = 3 = THIRd PLANET OF

? WHO IS MY MOTHER

NOT GREAT NOT MICTHY
NOT NOVEL SO
SIMPLE LIKE MY
GRAND FATHERS

17 = 8 = ∞ INFINIT

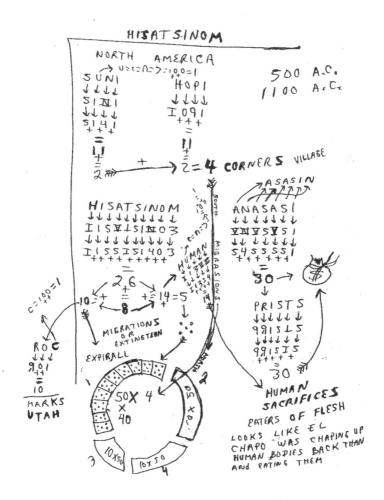

HISATSINOM

NORTH AMERICA

500 A.C.
1100 A.C.

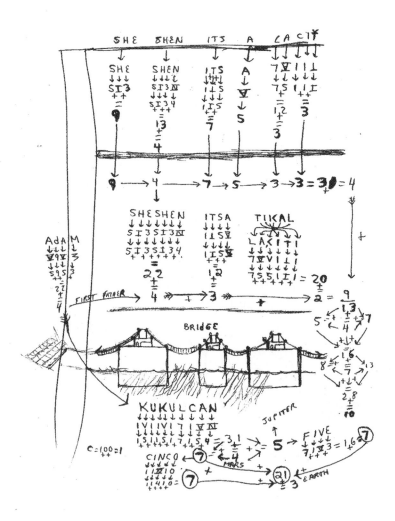

AS SUM IN

ASUMIN THAT ALL THE
BRIDGES OF COMUNICATION
AMONG THE NATIONS
HAVE BEEN BROKEN LEADERS
ABUSE THEIR CITICENS
THE LEADERS OF THE
RELIGIONS, SEPARATE THE
CITIZENS, IN THE PROCES
A GREAT CONFUSION IS CREATED
AMONG ALL LIVING, THE OPRESION
OF LEADERS FORCE IMMIGRATIONS
OF MULTITUDES, TURNING THEM IN
TO NOMADS, LIVING THEIR LANDS
BIHIND, INVADING LANDS, LOOKING AND
HOPING FOR BETTER CHANCES OF LIFE
AND THEY BECOME XTRANGERS IN XTRANGE
LANDS WHERE THEY ARE NOT WELCOME.
A GOOD LEADEAR OF A NATION WOULD SAY
THIS PEOPLE IS INVADING OUR LAND AND
AS HUMANS A GOOD LEADER WOULD SAY
WHOS MAKING THEM COME THIS WAY
A GOOD LEADER WOULD MEET WITH THE
LEADER OF THE NATION FROM WHERE
PEOPLE IS COMING FROM, AND ASK
WHAT ARE YOU DOING TO YOUR PEOPLE
WHY ARE THEY COMING TO OUR LANDS
HAVE YOU BECOME A BEAST TO YOUR
CITIZENS, ?
i YOU STOP OR I WILL STOP, YOU !
i A GOOD LEADER WOULD SAY !
TO A BAD LEADER.

CHAPTER 1
THE 68 PAGES
PLUS THIS FOUR

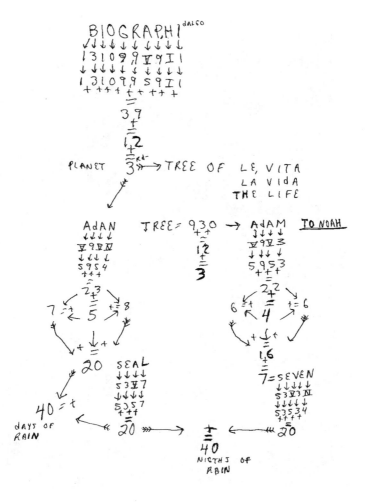

BIOGRAPHI ᵈᵃˡˢᵒ
↓↓↓↓ ↓ ↓ ↓↓↓ ↓
1 31099 ⅴ9I1
↓↓↓↓ ↓ ↓ ↓↓↓
1 31099 59I1
+++ + + + +++

3 9
+
1 2

PLANET 3 ᴿᵗ → TREE OF LE, VITA
 LA VIDA
 THE LIFE

AdAN TREE = 930 → AdAM TO NOAH
↓↓↓↓ +↑+ ↓↓↓↓
ⅴ9ⅴⅴ 1 2 ⅴ9ⅴ3
↓↓↓↓ 3 ↓↓↓↓
5954 5953
+++ +++

2 3 2 2

7 ⁼↑ 5 +⁼ 8 6 ⁼↑ 4 +⁼ 6

+ ↓ + + ↓ +

20 SEAL 1 6
 ↓↓↓↓
 53ⅴ7 7 = SEVEN
 ↓↓↓↓ ↓↓↓↓
 5357 53ⅴ3ⅴ
 +++ ↓↓↓↓
40 = † 20 ⋙ → 535,34
 +++
dAYS OF ← ← † ←⋘ 20
RAIN 40
 NICTHJ OF
 RAIN

CHAPTER 2

dAVID
↓↓↓↓↓
9 IV 19
↓↓↓↓↓
9 5 5 19
↑↑↑↑↑
29
+
=
11 ✳

ELEVEN

SOLOMON
↓↓↓↓↓↓
50 20 30 IV
↓↓ ↓↓↓↓↓
50 70 30 4
↑↑↑↑↑↑
19
=
10
TEN

dEGRES
↓↓↓↓↓↓
9 3 9 9 3 5
↑↑↑↑↑

3 + 8
+
=
11

4 ← + =
↓

6 = +

2

9
↓

±
=
11

17 SHIPS FROM
CADIS

+
=
21
+
=
3 → TREE (111)

LAS 3
CARABELAS

SHIPS
FROM
PUERTO
dE PALOS

TRIANGLE BERMUDA
OCTOBER EVELEN

THE MAY
FLOWER

1492

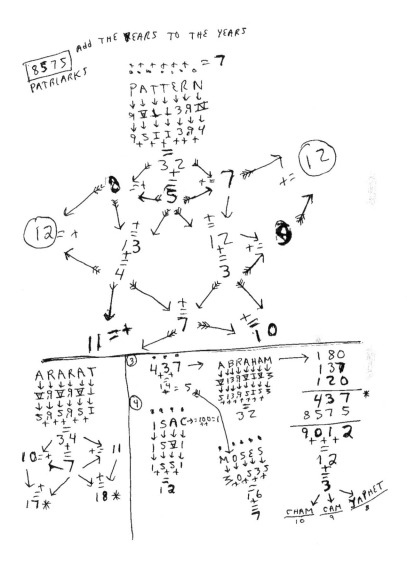

Add THE BEARS TO THE YEARS

8575
PATRIARKS

= 7

PATTERN

41

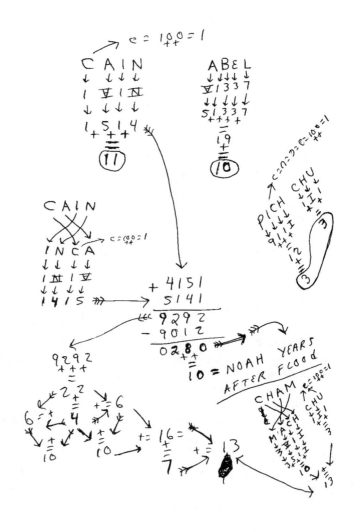

42

02/20

44

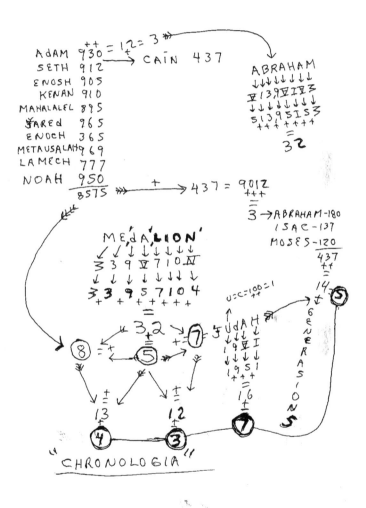

ADAM 930 ++ = 12 = 3 →→ CAIN 437
SETH 912
ENOSH 905 ABRAHAM
KENAN 910 ↓↓↓↓↓↓↓
MAHALALEL 895 V 13,9 V I V 3
JARED 965 ↓↓↓↓↓↓↓
ENOCH 365 5 1 3, 9 5 1 5 3
METAUSALAH 969 + + + + + +
LAMECH 777 = 32
NOAH 950
——————
8575 →→ + →→ 437 = 9012
 +++
 = 3 → ABRAHAM-180
ME'dA'LION' ISAC-137
339 V 710 IV MOSES-120
3 3 9 5 7 10 4 ——————
+ + + + + + + 437
= 32 ++
 = 14

3,2 → 7 U=C=100=1
8 5 JUdAH
13 12 = 16
4 3 7 GENERATIONS 5

"CHRONOLOGIA"

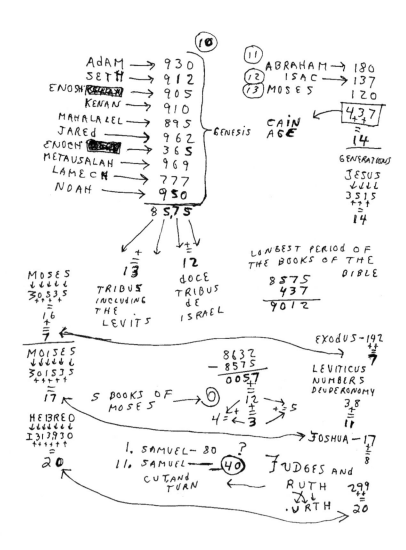

⑩

AdAM → 930
SETH → 912
ENOSH ~~KENAN~~ → 905
KENAN → 910
MAHALALEL → 895
JARED → 962
ENOCH ~~░░░~~ → 365
METAUSALAH → 969
LAMECH → 777
NOAH → 950

⟩ GENESIS

8 5,7 5

↙ ↓ ↓↓ ↓
+ +
1=3 12
 =
TRIBUS dOCE
INCLUDING TRIBUS
THE dE
LEVITS ISRAEL

MOSES
↓↓↓↓↓
30,535
+++++
=
1,6
=
7

⑪ ABRAHAM → 180
⑫ ISAC → 137
⑬ MOSES 120

CAIN
AGE ⟨ 4 3 7
 +++
 =
 14
 GENERATIONS

 JESUS
 ↓↓↓↓
 3515
 +++
 =
 14

LONGEST PERIOD OF
THE BOOKS OF THE
 BIBLE
8575
 437
9012

MOSES
↓↓↓↓↓↓
30,535
+++++
==
17

5 BOOKS OF
MOSES → ⓪

HEBREO
↓↓↓↓↓↓
1,313,930
+++++++
=
20

1. SAMUEL - 80
11. SAMUEL — ㊵
CUT AND
TURN

8632
− 8575
──────
005,7
 +++
 12
 =
4 = ← 3 → = 5

EXODUS - 192
 ++
 =
 7
LEVITICUS
NUMBERS
DEUDERONOMY
 3,8
 ++
 11

→ JOSHUA - 17
 1+
 =
 8

?

JUDGES AND
RUTH 299
↗↓ ++
.URTH =
 20

46

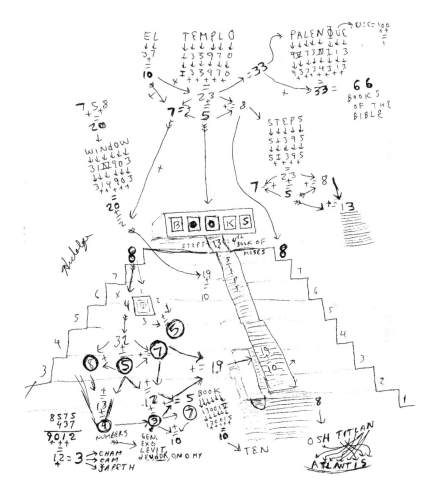

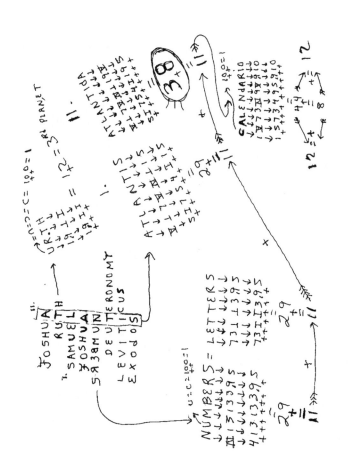

49

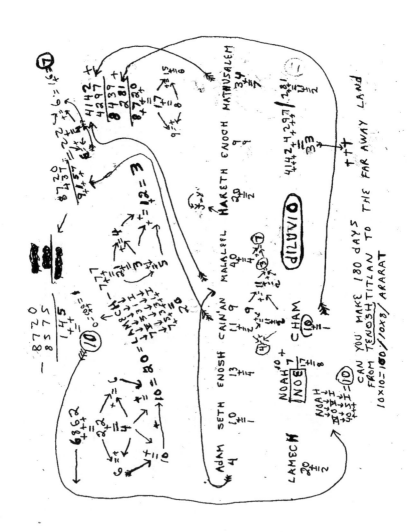

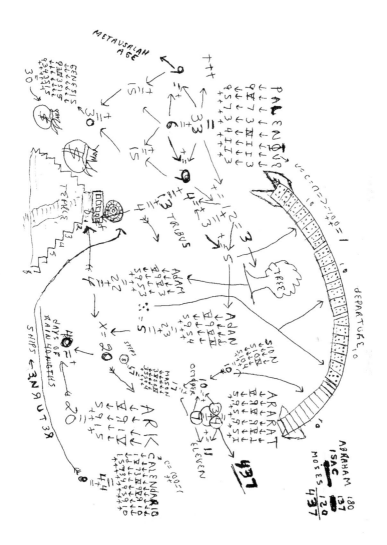

51

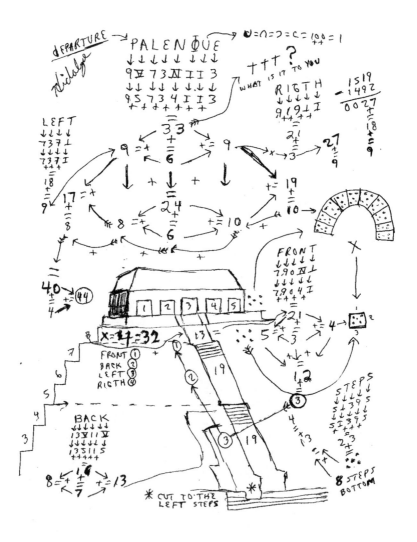

52

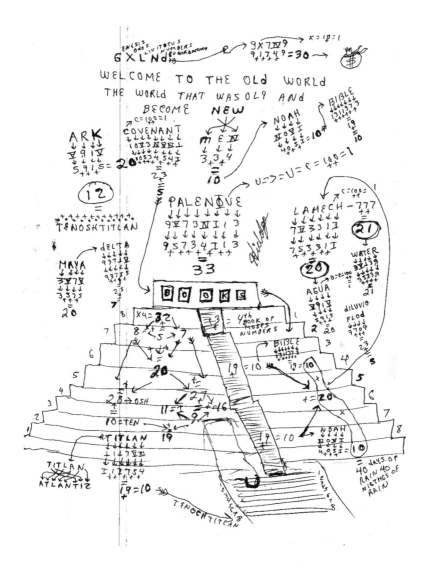

WELCOME TO THE OLD WORLD
THE WORLD THAT WAS OLD AND
BECOME NEW

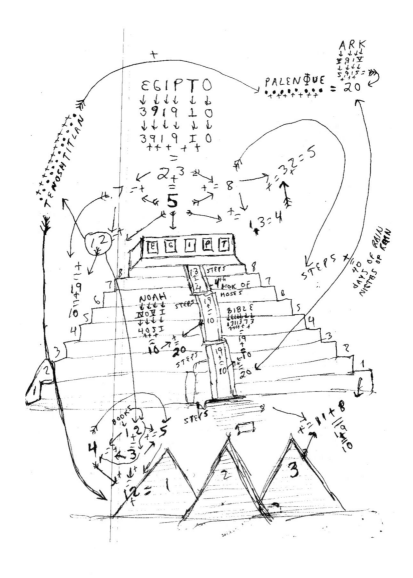

54

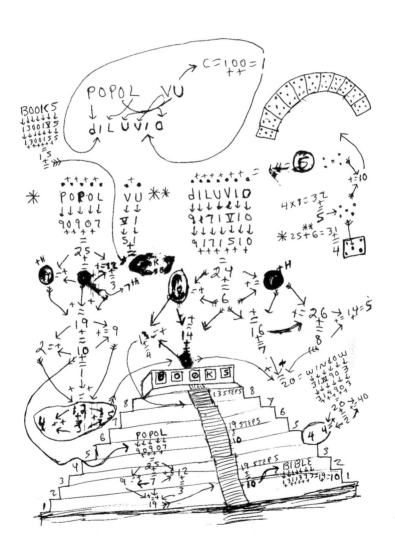

55

MISTERY OF

ATLANTIS ⟷ ATLANTIDA

$$29$$
$$\pm$$
$$11$$

LETTERS

$$29$$
$$\pm$$
$$11$$

NUMBERS

$$38$$
$$\pm$$
$$11$$

$U = \cap = \supset = C = 100 = 1$

$$29$$
$$\pm$$
$$11$$

$11 \times 4 = 44 \curvearrowright$ $C = 100 = 1$

CALENDARIO

$$44$$

$12 = \pm \quad \pm = 12$
$$8$$

LANGUAGES ORIGINATED FROM NUMBERS
AND LETTERS FROM NUMBERS THE
TRIBES OF THE CONTINENT
EUROASIATICOAFRICANO ORIGINATED FROM
THE 12 ~~TRIBES~~ ORIGINALL 12
TRIBES OF AMERICA, AND LE,VITA =
(ESPAÑOL) LA VIDA, OR, THE LIFE,(INGLES)(ITALIANO)

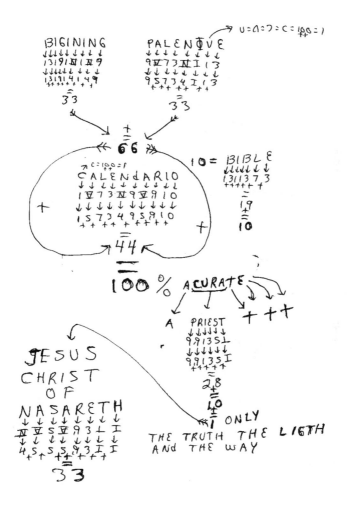

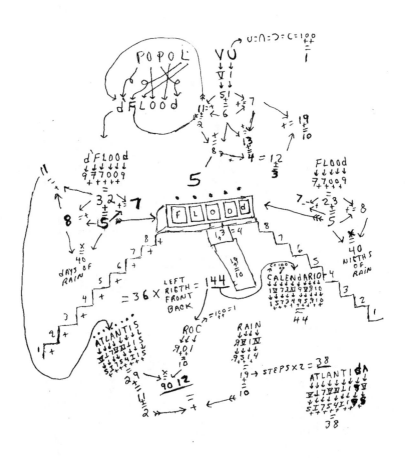

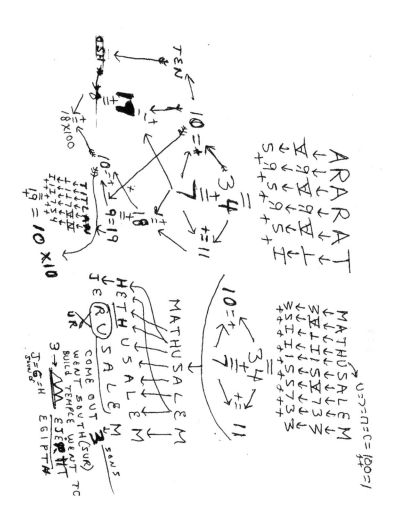

UNLOADING THE ARK APON ARIVEL
FADER WIFE 3 SONS AND WIFES AND THE CARGO'
OF ANIMALS → ANIMALS — AS ANIMALES

NOT LIKE THE HUMANS WHO ACT LIKE ANIMALS BEASTS,

MATHUSALEM

ANIMALES

V III III 3 3 V
5 4 1 3 3 7 3 5
+ + + 3 + 5 + 7 + 3 5

SALE (COME OUT)

ANI / MALES

SALE (COME OUT)

JESUS LEAD THEN EVERY STEP OF THE WAY

33

SALE = COME OUT WRENT
OR VENDER = FEE
SOUNDS LIKE FEMALES

FE = FAITH
→ FEITH → WRIGTH

WE MEN OR WOMEN OR MUJER

MEN HOMBRES
WEMEN

10 =
10 = 20 = HEBREO
5 4 1
3 3 4
+ +
20

I 3 1 3 9 3 0
I 3 1 3 9 3 0
+ +
20

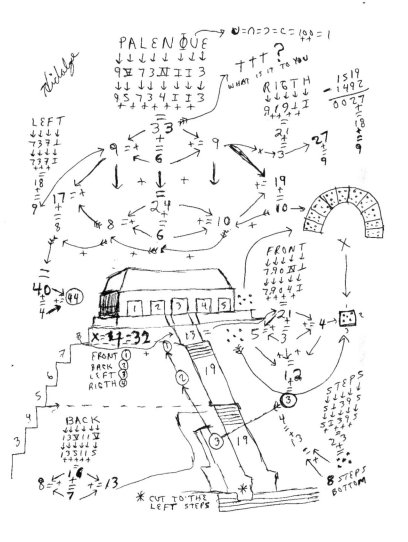

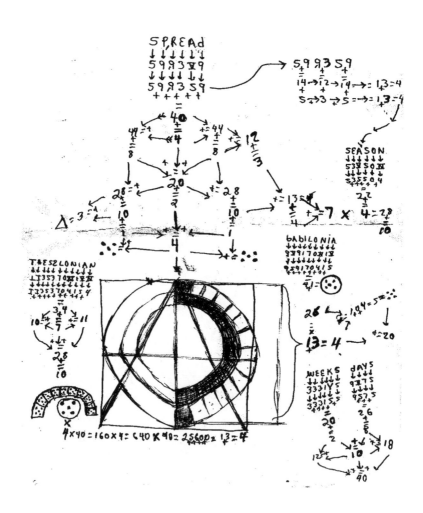

SPREAD

SEASON

THESZLONIAN

BAbILONIA

WEEKS dAYS

$4 \times 40 = 160 \times 4 = 640 \times 40 = 25600 = 1.3 = 4$

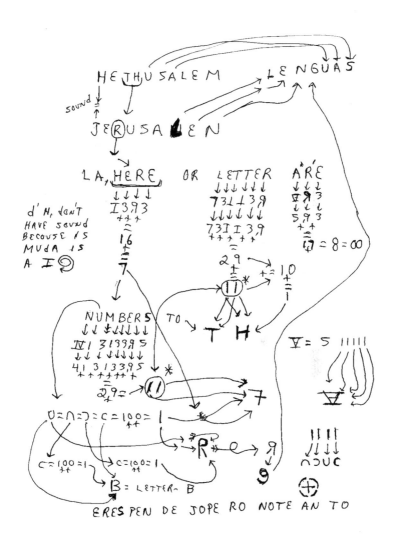

HETHUSALEM → LENGUAS

sound

JERUSALEN

LA, HERE, OR LETTER ARÉ

d'H, don't
HAVE sound
BECOUSE IS
MUdA IS
A

NUMBERS TO TH

$\overline{V} = 5$ IIIII

$U = \cap = \supset = C = 100 = I$

$C = 100 = I$ $C = 100 = I$

B = LETTER- B

ERES PEN DE JOPE RO NOTE AN TO

RAIDERS OF THE LOST
ARK
dePART,UR

U=∩=⊃= C = 100 = 1
 ++

PALENØUE ⟷ BIGINING

↓ ↓ ↓ ↓ ↓ ↓ ↓ ↓ ↓ ↓ ↓ ↓ ↓ ↓ ↓
9 Ⅴ 7 3 Ⅳ Ⅰ 1 3 13 19 1 Ⅳ 1 Ⅳ 9
↓ ↓ ↓ ↓ ↓ ↓ ↓ ↓ ↓ ↓ ↓ ↓ ↓ ↓ ↓
9 5 7 3 4 Ⅰ 1 3 13 19 1 4 1 4 9
 + + + + + + + + + + + + + +
 ‾‾ ‾‾
 33 + + + 33 + + +

U=∩=⊃=100=1
 ++

SUMARIAN

↓ ↓ ↓ ↓ ↓ ↓ ↓ ↓
5 1 3 Ⅴ 9 1 Ⅴ Ⅳ
↓ ↓ ↓ ↓ ↓ ↓ ↓ ↓
5 1 3 5 9 1 5 4
 + + + + + + +
 ‾‾
 33

PATTERNS
 ↓
ARARAT ⟷ LANDING RETURN TO
↓ ↓ ↓ ↓ ↓ ↓ AMERICA AFTER SETTLEMENTS
Ⅴ 9 Ⅰ 9 Ⅴ Ⅰ 14 9 2 IN THE
↓ ↓ ↓ ↓ ↓ ↓ + + + ARAUE NATIRNS
5 9 5 9 5 Ⅰ ‾‾ AND EUROPEAN
 + + + + + 16 NATIONS
 ‾‾ ±‾
 3,4 7
10 ±‾ ±‾ 11
 7 ELEVEN CRISTOBAL COLON AT THE △ BERMUDA
OCTOBER ±‾
 7

7 MISTERY OF THE 7

SEVEN → S.I.C.T.E

SE VEN

WE SAW

SI
YES

EXTRA
TERRAEJTRIALS
3 RD PLANET
3 ON EARTH

IT SEMS AS WE HAS SOME
VISITORS FROM OUT OF SOME
WHERE UPTHERE SOME BODY IS
WATCHING **US**

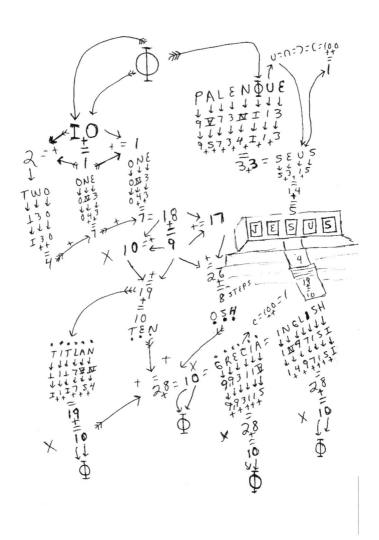

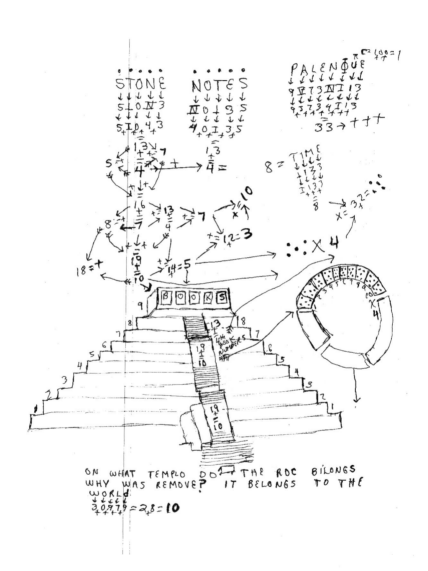

CHAPTER 3

BURDEN AGAINST THE
CHURCHES LEADERS
BURDEN AGAINST THE
NATION LEADERS

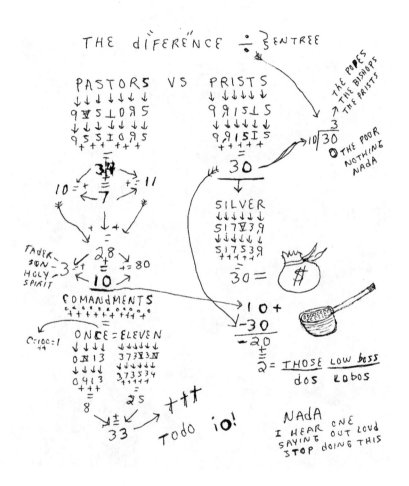

THE DiFERÉNCE ÷ 3 ENTREE

PASTORS VS PRISTS

THE POPES
THE BISHOPS
THE PRISTS

THE POOR
NOTHING
NADA

SILVER

TADER-
SON
HOLY
SPIRIT

COMANDMENTS

C=100=1

ONCE = ELEVEN

THOSE LOW bo55
dos lobos

NADA
I HEAR ONE
SAYING OUT LOUD
STOP DOING THIS

TODO ¡O!

74

...nderstanding,
nd those who complained will learn doctrine.

30 "Woe to the rebellious children," says the
LORD,
"Who take counsel, but not of Me,
And who devise plans, but not of My Spirit,
That they may add sin to sin;
2 Who walk to go down to Egypt,
And have not asked My advice,
To strengthen themselves in the strength
Pharaoh, —————————————→ RAMSES
And to trust in the shadow of Egypt!
3 Therefore the strength of Pharaoh
Shall be your shame,
And trust in the shadow of Egypt
Shall be your humiliation.
4 For his princes were at Zoan,
And his ambassadors came to Hanes.
5 They were all ashamed of a people who could
not benefit them,
Or be help or benefit,
But a shame and also a reproach."

6 The burden against the beasts of the South.

Through a land of trouble and anguish,
From which came the lioness and lion,
The viper and fiery flying serpent,
They will carry their riches on the backs of
young donkeys,
And their treasures on the humps of camels,
To a people who shall not profit;
7 For the Egyptians shall help in vain and to no
purpose.
Therefore I have called her
Rahab-Hem-Shebeth.[20]

8 Now go, write it before them on a tablet,
And note it on a scroll,
That it may be for time to come,

76

'SOME SAId THAT A COIN IS A SEEd,
I SAY THIS WORdS ARE SEEd

LAS MONEdAS NO CRECEN EN LOS
SURCOS LAS SEMILLAS SI

IF YOUR SEASON IS GOOd YOUR SEEd
WILL GROW ABUNdONEtLY WATER IT
CARE FOR IT ANd THAN HARVEST IT
THE bAd SEEd WILL BLOW AWAY WITH
THE (WINd) KEEP THE GOd SEEd, GIVE
TO WHO HAd A bAd SEASON, AS FOR YOU
don't KNOW WHEN YOU WILL HAVE A
bAd SEASON, SAVE SOME FOR THE DRY
SEASON, SAVE SOME FOR THE EARTH
AS FOR THE EARTH WILL MULTIPLY IT
FOR YOU IN ABUNdANCE, WHEN YOU
HAVE TO MUCH, SHARE IT WITH
THOSE WHO, PLANTEd COINS ANd
STILL WAITING FOR THEIR COINS TO
GROW IN PLANTS, BE CAREFULL WHO YOU
SHARE YOUR HARVEST WITH AS FOR
SOME WILL BECOME WEALTHY FROM
IT, AS FOR HOW THEY COME TO
YOU, THEY ALSO GO TO 1000'S OF
OTHERS, NOT ASKING BUT DEMANdING
IN THE NAME OF GOd GIVE ME
GIVE ME GIVE ME, SO ROW
sodom

PUT IT ON THE RIGTH MIND

HOPE THIS WORdS FALL ON THE
HOPE IT DOESNT FALL ON THE
SUBTITLES
HOPE
WIND
MIND

QWEST Y ON

1.- HAVE I EVER BUILD A TEMPLE? NO
2.- HAVE I EVER PUT MY SELF IN ONE? NO
3.- HAVE I EVER STOOD IN FRON OF A
 CROWD AND SAID GIVE TO GOD? NO
4.- HAVE I EVER CLAIM TO BE THE
 LIGTH THE TRUTH AND THE WAY? NO
5.- HAVE I EVER BENEFIT FROM THE LABOR
 OF THE LABOR OF SHEEPS? NO
6.- IF I EVER BUILD A TEMPLE WILL
 I SAY I'M GOD ?••••••• NO
 N
 O
 4 O

Y = WHY → ONLY JESUS

dELTA
9 37 I V
9 37 I S
2 5
= 7⌐

HE

WHY?
HE IS LIKE
THE FADER
7 I 9 3 9
7 5 9 3 9
= 33

0 I 77
0 4 7 7
18 = CHRIST
 I 9 15
 I I 9 15 I
 = 18

c = 100 = 1

SEUS

3
→ 33 → ✝✝✝

¿ W,HERE ARE MY ACUSERS ?
¡ I DON'T KNOW FADER! WHERE DID YOU SEND THEM?

r mast,

is divided;

"I am sick";
be forgiven

ear;

s in it,

forth from

16 "Se... the book of the LORD, and read
Not ... shall fail;
No ... lack her mate.
For My mouth has commanded it, and His
 Spirit has gathered them.
17 He has cast the lot for them,
And His hand has divided it among them with
 a measuring line.
They shall possess it forever;
From generation to generation they shall dwell
 in it."

35

The wilderness and the wasteland shall be
 glad for them,
And the desert shall rejoice and blossom as
 the rose;
2 It shall blossom abundantly and rejoice,
Even with joy and singing.
The glory of Lebanon shall be given to it,
The excellence of Carmel and Sharon.
They shall see the glory of the LORD,
... our God.

and Jerus
altar?"...
8 "Now
master the
thousand
put riders
9) "How
least of my
Egypt for c
this land to
against thi
11 Then I
Rabshakeh
maic, for w
in Hebrew
the wall."
12 But the
...and not to

I SENd YOU THE
SHIELd
I SENd YOU THE
SWORd
I SENd YOU THE
SPEAR
I SENd YOU THE
AR`MOR
HERE I SENd YOU THE
HELMET
↓↓↓ ↓↓↓
I 37 3 3↓
↓↓↓ ↓↓↓
I 37 3 3 I
+ + + + + +
‗
18 =

C = 100 = 1
+ +

ANdREW
↓↓↓↓↓
VII 99 3 3
↓↓↓↓
↓ 99 3 3
5 + + + +
‗
33
↓

A TRUE JEHOVA
WITNESS WHO
WAS THERE ON
THAT dAY ANd
ON THAT HOUR

NOT LIKE THE
FOOLS WALKING
AROUNd iOH! WE
COME IN THE NAME
OF JESUS
FALSE FALSE
FALSE FALSE

CHRIST
↓↓↓↓↓↓
I I 9 I 5 +
↓↓↓↓↓↓
I I 9 I 5 I
+ + + + + +
‗
18

→PUT IN, ON YOUR HEAd MAKE A
dEEN WITHIN YOUR HEAd ANd SEAL
IT SO THE "SERPIENTS" dON'T
COME IN TO YOUR GARd dEEN OF
EdEN — MIGTHY ANGEL OF MY FAdER
WITH YOU GUIdING ME, HOW CAN THEY

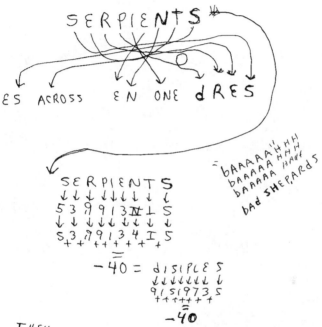

SERPIENTS

ES ACROSS EN ONE dRES

SERPIENTS
↓↓↓ ↓↓↓↓ ↓ ↓
5 3 9 9 1 3 Ⅳ ⊥ S
↓↓ ↓↓↓ ↓↓ ↓ ↓
S 3 9 9 1 3 4 I S
+ + + + + + + +

−40 = dISIPLES
↓↓↓↓↓↓ ↓
9 (5 (9 7 3 S
+ + + + + + +
−40

= bAAAAA'' H H
bAAAAA H H H
bAAAAA HAHE
bAd SHEPARdS

THEY WILL COME TO YOU DISGAIdS
AS THE PRIESTS IN dRESS AS dISIPLES
ANd THEY WILL SAY IN THE NAME
OF JESUS WE COME THEY WILL
BUILd TEMPLES THEY WILL PUT THEIR
SELFS IN IT, ANd THEY WILL TELL YOU
GIVE, GIVE, TO GOd, ANd THEY WILL
MAKE THEIR LIVING, FROM YOUR LABOR
ANd THEY WILL CLAIM YOU AS THEIR FLOCK

IdHOLLS = PRISTS
↓↓↓↓↓↓ ↓↓↓↓ ↓↓
19I0775 9,915⊥S
+ + + + + + ↓↓↓↓↓↓
= 9,915IS
30 + + + +
 =
 30

WORSHEEPING PRISTS IIS LIKE
WORSHEEPING IdHOLLS

FOR 2000 Y'EARS THEY HAVE
NOT SHINE IN THIS WORLd
OF dARKNES, ANd THE MORE OF
THEM IT GETS dARKER ANd
dARKER, THERE IS ONLY
(ONE) LIGTH (ONE) TRUTH ANd
(ONE) WAY

2 + ⟶ ⟶ 1 = 3 FATHER
 SON
 HOLY SPIRIT

 ↑C=C= 100 =1
 JESUSCHRIST OF
 ↓↓↓↓↓↓↓↓↓↓ NASARETH
3 2 3S1S1I9151 ↓↓↓↓↓↓↓↓
 ↓↓↓↓↓↓↓↓↓↓ IIV5Y93⊥I
 3S,1S1I9,1SI ↓↓↓↓↓↓↓↓
 + + + + + + + + 4555,931I
 = + + + + + + +
 32 =
 33

 + + +

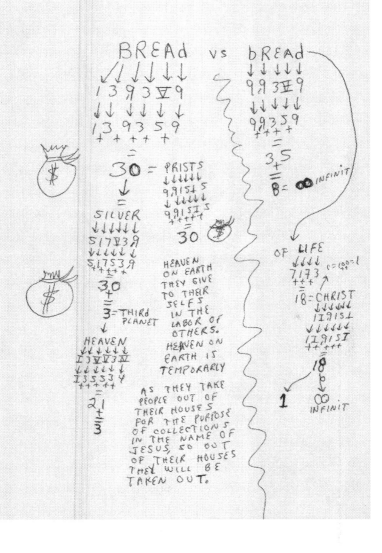

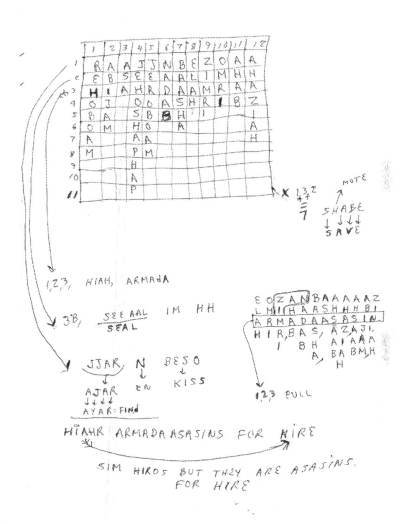

| | 1 | 2 | 3 | 4 | 5 | 6 | 7 | 8 | 9 | 10 | 11 | 12 |
|---|---|---|---|---|---|---|---|---|---|----|----|----|
| 1 | R | A | A | J | J | N | B | E | Z | O | A | A |
| 2 | E | B | S | E | E | A | A | L | T | M | H | H |
| 3 | H | I | A | H | R | D | A | A | M | R | A | A |
| 4 | O | I | | O | O | A | S | H | R | I | B | Z |
| 5 | B | A | | S | B | ■ | H | I | | | | |
| 6 | O | M | | H | O | | A | | | | A | |
| 7 | A | | | A | A | | | | | | H | |
| 8 | M | | | P | M | | | | | | | |
| 9 | | | | H | | | | | | | | |
| 10 | | | | A | | | | | | | | |
| 11 | | | | P | | | | | | | | |

X $\begin{array}{r} 13^2 \\ +7 \\ \hline 7 \end{array}$

MUTE
SHABE
↓ ↓↓↓
SAVE

123, NIAH, ARMADA

3B, SEEAAL IM HH
 ——————
 SEAL

JJAR, N BESO
 ↓ ↓
AJAR ᴇN KISS
↓↓↓↓
AYAR = FIND

EOZANBAAAAAZ
LMIHAARSHHHBI
ARMADAASASIN
HIR,BAS, AZAJI.
 I BH AIAAA
 A, BA BMH
 H

123 PULL

HIAHR ARMADA ASASINS FOR HIRE

SIM HIROS BUT THEY ARE ASASINS.
 FOR HIRE

89

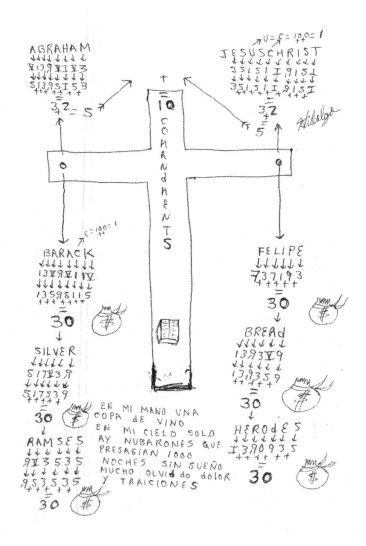

EN MI MANO UNA
COPA DE VINO
EN MI CIELO SOLO
AY NUBARONES QUE
PRESAGIAN 1000
NOCHES SIN SUEÑO
MUCHO OLVIdo dolor
Y TRAICIONES

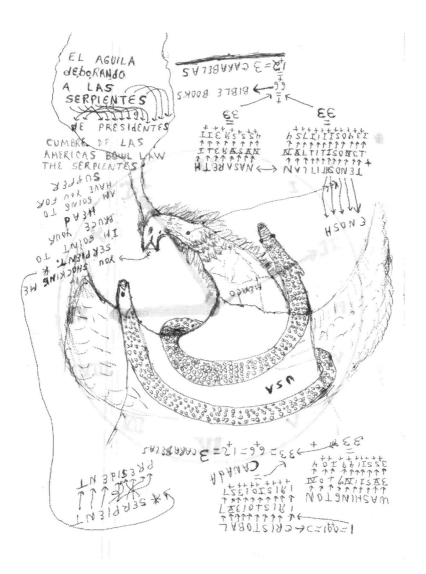

EL AGUILA
deborando
A LAS
SERPIENTES
DE PRESIDENTES

CUMBRE DE LAS
AMERICAS BOWL LAW
THE SERPIENTES
SUPPER

AN GOING TO
HAVE YOU FOR
HEAD
BRUCE
IM GOINT TO
SERPIENT *
YOU ←

SHOCKING ME

12=3 CARABELAS

6/6 ← BIBLE BOOKS
I

33
ILERS*SS*
45*S*9311
ITERASAN
NASA
NASARETH ←→

33
I3HOSIIIIS7H
SALTITISONCT
NV1ILUBON31
TENOSHITILAN

ENOSH

MEXICO

USA

33 *** + 33² + 6²+6=12²= 3 CARABELAS

CANADA

PRESIDEN T
*# SERPIENT

WASHINGTON
3ASIINY TOM
IV
3331I*9*1D4

1=00I=2→CRISTOBAL
IRISIOI37
IRISIOI37
1P15IOI357

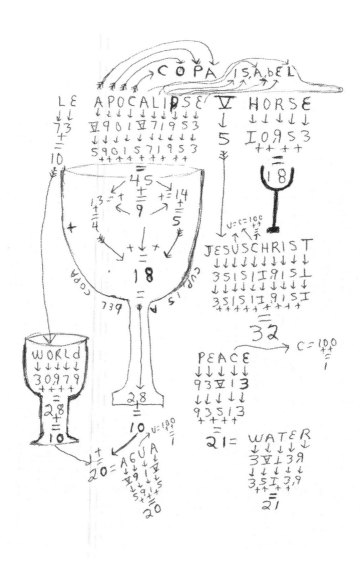

PER,MI,SION

I don't know who is in charge
of giving per (ME)sion to
rewrite the BIBLE but (MANY)
↓
MONEY

bibles have been rewriten →MONEY
and he who claims to be the
most high authority in the
church don't do anything
to make sure that if is going
REW
PELEG
SHILAH
to be rewriten, it mast be
↳ ~REWRITEN, RIGTH

PER
↓↓↓
9 3 9
+ +
2 1
↓ ↗ FADER
→ SON
3 ↘ HOLY
 SPIRIT

↓ ↙
ME MISION ≫

RIGTH
↓↓↓↓ ↓
9 1 9 ⊥ I
↓↓↓↓ ↓
9 1 9 I I
+ + +
2 1
↓ ↗ FADER
↙ SON
3 ↘ HOLY SPIRIT

MI
↓ ↓
3 1
=
4th BOOK OF
MOSES
NUMBERS

SION
↓↓↓↓
1 3 5 9
↓↓↓↓
1 0 5 9
+ + + 4
=
10
COMANDMENTS

INGLISH
I→1
I→1
I→1 N→9
I→1 N→9 G→3
I→1 N→9 G→3 L→5
I→1 N→9 G→3 L→5 I→1
I→1 N→9 G→3 L→5 I→1 S→1 H→8

28
—— = 10
2

B I B L E
3+9+2+5+1+1
—————————— = 10
10

DE ACUSER
D→4
E→5
A→1
C→3
U→3
S→1
E→5
R→9

DECEMBER 12

24 TWENTY FOUR
1+2
——— → 10
3

FALSE SON HOLY SPIRIT

IN A LITTLE BOOK OF SICRETS ITS WRITEN

GOD ABUSED THE PRISTS...THE MORE OF YOU THE MORE SIN IN THE WORLD........

XTRANGE BUT TRUE THE INGLISH LET IT AS IT WAS WRITEN, BASE ON THE MXENT AND THE CHANGE OF IT, SOME PRISTS IN THE SOUTH MADE A CHANGE ON THE SCRIPTURES AND WHEN I SAID SOUTH, IT GOES PAST MEXICO (EL SALVADOR)

SAL BAJ DOR
BITHEY MALA PUERTA

Y dios JEHOVA ACUSA A ISRAEL
DON'T CHANGE TITLES ON ME

YOU CANT CHANGE WHAT IS WRITEN.

IF WHAT ITS WRITEN ITS NOT CONVINIENT TO YOU AND BECAUSE ITS NOT CONVINIENT TO YOU, YOU DECIDED TO CHANGE THE LITTLE PARRAFO WITH THE PURPOSE ON MIND TO GO AROUND ACUSING OTHERS OF SIN, WHEN IT IS YOU WHO CHANGE THE WORDS FOR YOUR OWN CONVINIENCE

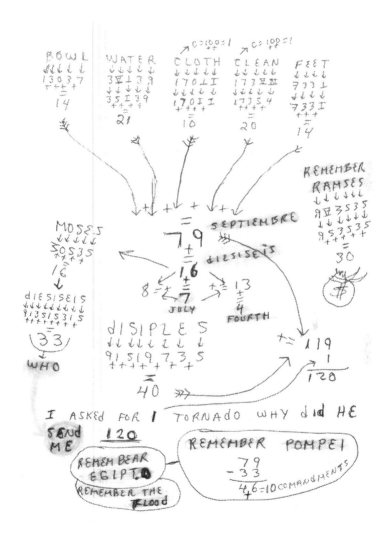

95

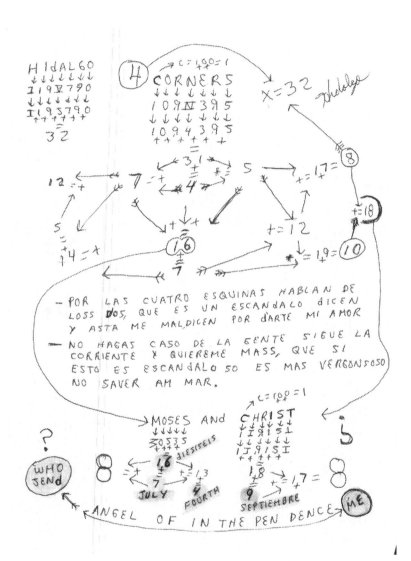

WHEN A MESSIAH COMES TO THE THIRD PLANET
THE SHEPARDS KEEP WATCH ON THEIR FLOCKS
DAY AND NIGTH, AS FOR THEY KNOW THE ONES
WHO SERV THEM OR THE ONES THEY FEED
THEIR SELFS FROM (SHEEPS) ARE ABOUT TO BE
TAKEN AWAY FROM THEM, AND THEY KNOW THAT
THEY WILL HAVE TO HARVEST THEIR OWN FOOD
WITH THE LABOR OF THEIR ON HANDS UNTILL
THE DAY THEY DAY (die)

FROM THIS TREE YOU SHALL NOT EAT

TILLERS OF THE LAND, SO MUCH OUT OF THE
WOMB OF THE EARTH IS BEEN TAKEN SO MUCH
IS RIQUIRE,

STEEL COPPER BRONCE SILVER GOLD NIQUEL OIL
CIRCONIUM PLATONIUM STUPIDUMIUM YOU HAVE TRASH
YOUR PLANET

IF I PUT ALL THE <u>AGES</u> OF THE
PATRI<u>ARKS</u> INCLUE,dING CAIN ANd I
COME TO A 9012 NUMBER

$\downarrow\downarrow\downarrow\downarrow$
9 0 1 2
$\uparrow\tilde{\approx}\uparrow$
1 2
$\tilde{+}$

8575+437
PATTERN

RE,3,VE = <u>RETRIEVE</u>

AGES
$\downarrow\downarrow\downarrow\downarrow$
⊽ 9 3 5
$\downarrow\downarrow\downarrow\downarrow$
5 9 3 5
$\uparrow\uparrow\uparrow\uparrow\tilde{+}$
2 2 = AdAM
$\downarrow\downarrow\downarrow\downarrow$
⊽ 9 ⊽ 3
$\downarrow\downarrow\downarrow\downarrow$
5 9 5 3
$\tilde{+}$
2 2

44 = +
$\tilde{+}$
8

30 = 💰

$\downarrow\tilde{\pm}\downarrow$

PREISE THE LORd
$\downarrow\downarrow\downarrow\downarrow\downarrow$
9 9 3 1 5 3
$\uparrow\uparrow\uparrow\uparrow\uparrow\tilde{+}$
30 → 💰

PROFET,A NAN SARO
SI TENGO QUE MORIR
QUERRE QUE ESTES AYI
MIRAN, DO ME, PARA MORIR
HIGUAL, COMO MUEREN LOS POBRES

SIN

ESPAÑOL ←——→ <u>INGLES</u>

SIN → TRANSLATION — WITHOUT

RIFET WFLC

WITHOUT SIN WE COME IN
TO THE WORLd, IN TO
A WORLd OF SIN, A WORLd
FULL OF CORRUPTION, TEARS,
ANd PAIN, A FOOL EACH
WORLd OF VANITY, ANd
dARKNES, AND AMVYTION
EVERY BODY WANTS TO RULE
THE WORLd, AS SOON AS
WE ARRIVE IN TO THIS
PLANET WE HAVE SOME BODY
SCREAMING IN OUR FACES
YOURE A SINER YOUR NOT
WORTHY OF LIVING, THERE FOR
YOU WILL BE MY SERVENT,
COME TO CHURCH ANd PAY
YOUR dOES,
TORNS IN MY HEAd

98

THE MISTERY OF THE
"ANTICHRIST"

IS LIKE A double sided sword

sided sword double
↓↓↓↓ ↓↓↓↓ ↓↓↓↓↓↓
S1939 S3099 901973
↑↑↑↑ ↑↑↑↑↑ ↑↑↑↑↑↑

2 7 2 6 2 9
+ + +
9 8 11

1 9
+
-10%

HE OR THEY PUT
THEIR SELFS IN
TEMPLES THEY BUILD
TEMPLES THEY ASK
TO BE WORSHEEP AS
GODS, AS FOR WHEN THEY
ASK FOR OFERINGS THEY
SAID GIVE TO GOD, GIVE TO
GOD, AND EVERYTHING COLLECTED
THEY RECIEVE IT THEY FALL
ON THAT PRO, FEE, SEE,
AND YET THEY DON'T UNDERSTEND.
NOT 1, NOT, 2, NOT 3 BUT
BY THE 1000'S LIKE JESUS SAID
IN MY NAME THEY WILL COME

ANTICHRIST
↓↓↓↓↓↓↓
VN1119151
↓↓↓↓↓↓↓↓
S41119151
↑↑↑↑↑↑↑↑↑

2 9
3 = + + + 10
4 2
+ +
= 5
1 5
6

DONES AND DONT'S

1: WRITE LETTERS TO THE SEVEN CHURCHES
MORE THE ONE
PLURAL
=
MANY
=
R NUMBERS

LETTERS
73±13,95
73II395
29
÷
II
2

NUMBERS
1 3,13,95
4 13133,95
29
÷
II
2

4th BOOK OF MOSES

dONE ☑

FREE WAS GIVEN TO ME
FREE I SEND TO THEM
dONE ☑
Hidalgo

2: DONT'S, THEY WILL NOT SPREAD IT OUT
AS FOR IF THEY dO THEY WILL NO LONGER
WILL BE ABEL TO COLLETCT dONE,A,SEE,ONS
FROM PEOPLE.
AND YET THEY CONTINUE MAKING THEIR
FALSE CRUSSAd,HAS,
✝ SAd THUS GIVE ME GIME ME
3: THEY STAMBLE ON THEIR OWN (IN THE NAME OF JESUS
TEACHINGS. WE CAME)

donation=fee
↓↓↓↓↓↓↓↓
9ONIIION
↓↓↓↓↓↓↓↓
904,SIIO4
↑↑↑↑↑↑↑↑

24
8 ÷ 6 ÷ 10

+ + +

24
8 ÷ 6 ÷ 10

+ + +

24
6

SPREAd → FREE
↓↓↓↓↓↓↓
5993I9
↓↓↓↓↓↓
599359
↑↑↑↑↑
=
40= disiples
↓↓↓↓↓↓↓↓
91519735
↑↑↑↑↑↑↑
=
40

JESUS TO THE
disiples AS I GIVE
TO YOU FREE GO
OUT AND GIVE IT
FREE

LAST LETTER I SEND TO ___DONE
THE CHURCHES, ☑

HAVE IT YOUR WAY
I dWELL WITH YOU
NO MORE
 dATED 6-5-12
 AS VENUS PASSOVER
 THE SUN

✝

I didn't ASK
FOR ONE
SINGLE CENT

☑ dONE

Hidalgo.

$\nearrow \angle\angle \overset{18^\circ}{++} = 1$

CHURCHES

↓ ↓ ↓ ↓ ↓ ↓ ↓ ↓

1 I 1 9 1 1 3 5

+ + + + + + + +

$\overline{\underline{22}}$

6 ÷ ++ ← $\overset{+}{\underline{4}}$ +÷ 6

+ ↓ + ÷= 1,2 = 3RR PLANET

$\underline{1,6}$

7 SEVEN CHURCHES

7 3

↓ + ↓

COMANDMENTS 10 = EARTH

↓↓↓↓

LETTERS I SENT, ▬ 3891I

THE CHURCH IS NOT ↓↓↓↓

FOR BU**SINE**S 8591I

AND YET THEY CONTINUE + + + +

USING IT FOR PERSONAL $\underline{19}$ = 10

WEALTH

MEXICO $x = 10 = 1$ $c = 100 = 1$ ⟶ CUBA $c = v = v = 7 = 100 = 1$

HOW MUCH MONEY
WAS COLLECTED
IN THE PREVIUS dAYS
OF HIS ARRIVEL
HOW MUCH WAS LEFT
IN CUBA, ANd WITH
WHAT PURPOSE ANd
HOW MUCH WENT TO
ROME

d'dOPE
MONEY ROSES ANd
6UNS!
I LOb A RAINY
dAY

WHY DID THE MEETING LASTED ONLY
30 MINUTES ⟶

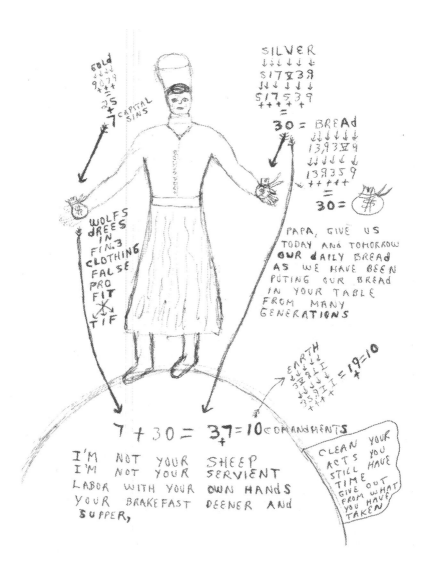

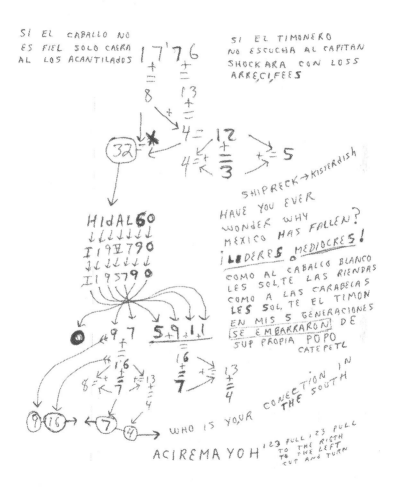

SI EL CABALLO NO
ES FIEL SOLO CAERA
AL LOS ACANTILADOS

SI EL TIMONERO
NO ESCUCHA AL CAPITAN
SHOCKARA CON LOSS
ARRECIFEES

1.7.7.6

32

HIDAL60

I19I790

I19579 0

SHIPRECK→KISSERDISH
HAVE YOU EVER
WONDER WHY
MEXICO HAS FALLEN?
¡LIDERES MEDIOCRES!
COMO AL CABALLO BLANCO
LES SOLTE LAS RIENDAS
COMO A LAS CARABELAS
LES SOL TE EL TIMON
EN MIS 5 GENERACIONES
SE EMBARRARON DE
SUP PROPIA POPO
CATEPETL

9+7 5+9+1+1

WHO IS YOUR CONECTION IN THE SOUTH

ACIREMA YOH 123 PULL 123 PULL
TO THE RIGTH
TO THE LEFT
CUT AND TURN

IN THE TIME OF MOSES THERE WAS
RAMSES

IN THE TIME OF JESUS THERE WAS
HERODES

IN MY TIME I HAVE BARACK AND
FELIPE

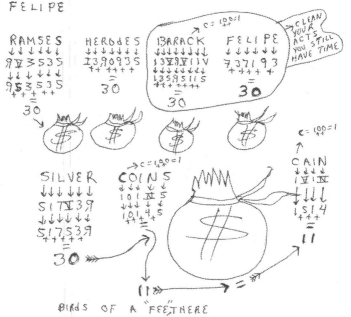

BIRDS OF A "FEE" THERE

CHANCES ARE

IN THE TIME OF ███ FADER←ADAM
LIFE WAS SPARE. ↙
IN THE TIME OF ₵NOAH LIFE WAS SPARE
IN THE TIME OF FADER→ABRAM LIFE WAS
SPARE. ↓ ←
IN THE TIME OF MOSES LIFE WAS SPARE
IN THE TIME OF FADER→dAbid LIFE WAS
SPARE, ↓ ←
IN THE TIME OF SOLOMON LIFE WAS
SPARE,
↙ ↷
IN THE TIME OF FADER JESUS LIFE WAS
SPARE, FROM THERE ON TO NOW LIFE
IS BEEN LIKE,A,SPEAR
→ <=100=1

LIFE = CHRIST

SOME ONE TOLD ME GIVE YOUR LIFE TO
CHRIST, AND I SAID MY LIFE HAS
ALL WAYS BILONG TO THE ONE WHO
GAVE IT TO ME, AND TO HIM I WILL
RETURN IT, IN THE MOMENT HE ASKS FOR
IT. FOR HIM IS THE LABOR OF MY HANDS
I'M NOT HERE BY ACCIDENT OR CHANCE
FROM HIM I WAS SENT TO HIM
I WILL RETURN. ¡FADER IT IS YOUR WILL
NOT MY, YOUR TRONE ¥S FOR EVER YOURS
NOT MY, I WILL TEHNT TO SIT ON IT NOT.

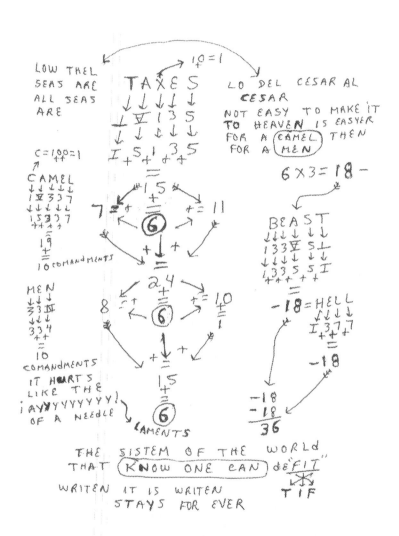

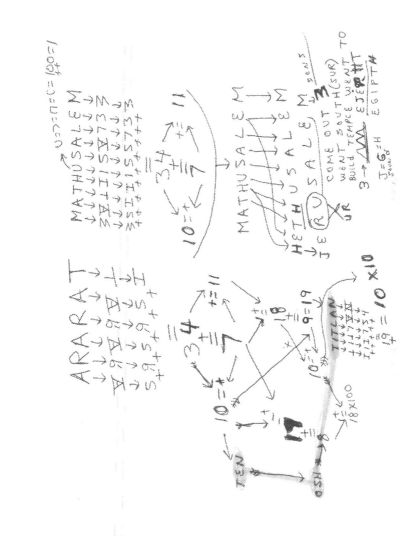

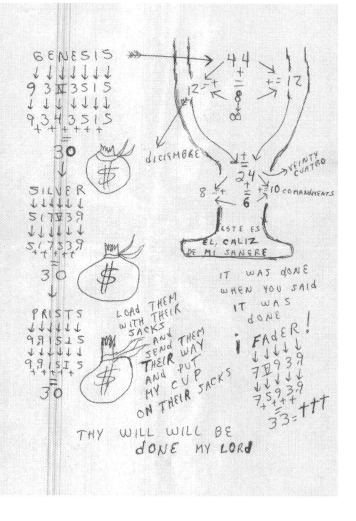

TO MR. GEORGE, CLONY
AND HIS FADER

↓↓↓↓
7̶ 8 9 3 9
↓↓↓↓
7̶ 5 9 3 9
+ + + +
‾‾‾‾
3 3 ———→ † † †

SAW
I SOW TWO MEN STANDING IN
DEFENCE OF JUSTICE AS
UNJUSTICE WAS TAKING PLACE
I WAS SPECKTING TO SEE THE
POPE STANDING FOR THIS PEOPLE
OR THE GREATEST AUTHORITY IN
THIS PLANET IN REPRESENTATION
OF JUSTICE, INSTEAD I SAW
TWO ORDINARY MEN, WELL THE
POPE WAS TO BUSY COLLECTING
DONETIONS AND COUNTING HIS
MONEY, WHILE THE CITIZEN OF
MANY NATIONS ARE BEEN
MASACRETED BY THEIR OWN
LEADERS, USING HIGHLY TRAINED
ASESINS, "SOLDIERS"

CHAPTER 4

CRONOLOGIES
· · ● · · ● · · · · · · ● $\frac{11}{2}$

LENGUAGES

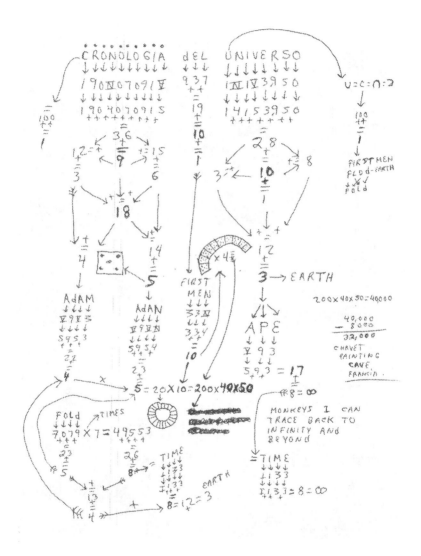

dIOS
↓↓↓↓
9 I O S
↑↑↑↑
=S
7 ←→ 6 ←→ 11

i 0 0 = I

E N EL PRIMER dia dios creo
↓↓↓↓↓↓↓↓↓↓↓↓↓↓↓↓↓↓↓↓↓
3 Ⅲ 3 7 9 i 3 3 9 9 i Ⅲ 9 i 0 5 i 9 3 0
↓↓↓↓↓↓↓↓↓↓↓↓↓↓↓↓↓↓↓↓ → 3 4 3 7 9 9 i 3 3 9 9 i 3 9 i 0 5 i 9 3 0
3 4 3 7 9 9 i 3 3 9 9 i 3 9 i 0 5 i 9 3 0
↑↑↑↑↑↑↑↑↑↑↑↑↑↑↑↑↑↑↑↑↑

9 4
=0 =3 =7
=4

↓↓↓
i 2
=3

C = 9 9 = i

EN EL SECUNdo dia dios creo
↓↓↓↓↓↓↓↓↓↓↓↓↓↓↓↓↓↓
3 Ⅲ 3 7 5 3 9 i Ⅲ 9 6 9 i Ⅲ 9 i 0 3 i 9 3 0
↓↓↓↓↓↓↓↓↓↓↓↓↓↓↓↓↓ → 3 4 3 7 5 3 9 i 4 9 0 9 i 3 9 i 0 3 i 9 3 0
3 4 3 7 5 3 9 i 4 9 0 9 i 5 9 i 0 3 i 9 3 0
↑↑↑↑↑↑↑↑↑↑↑↑↑↑↑↑↑↑↑

I 0 =0 =i
= =0 =i
=

3

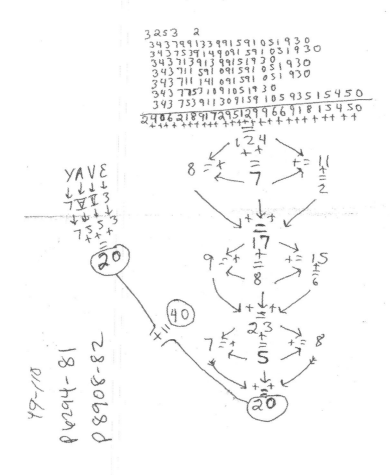

116

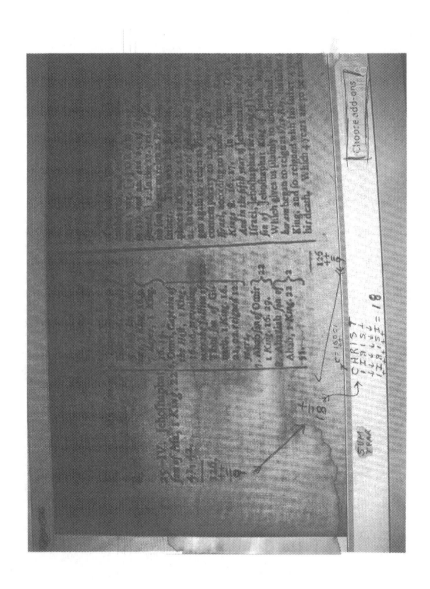

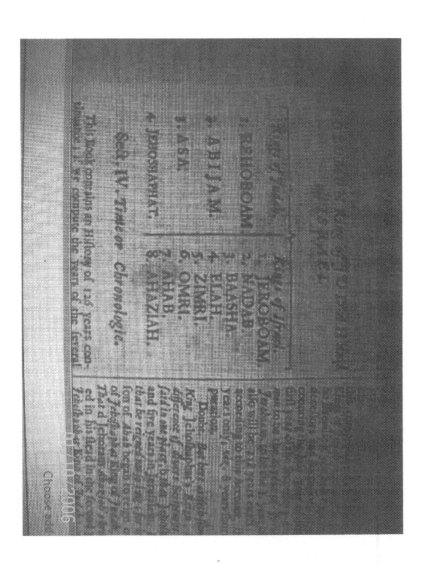

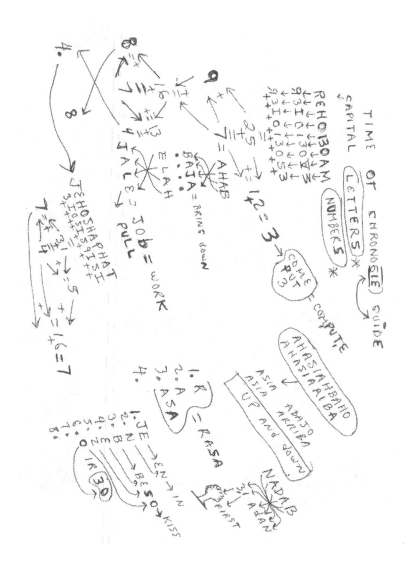

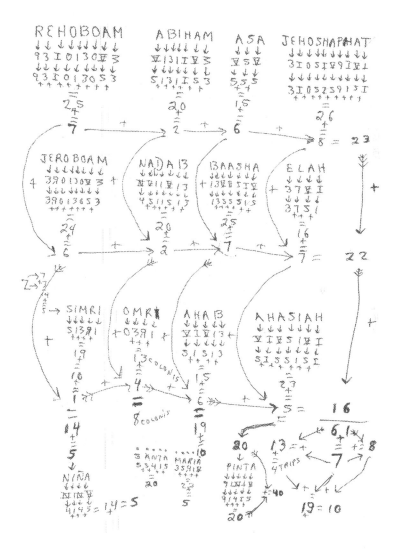

WHO AM (I) TO SAY WHO
IS MY MODER WHO AM (I)
TO SAY WHO ARE MY BRODERS
ANd WHO AM (I) TO SAY WHO
IS MY FADER.

THE
5th HAS PASSED
THE 6th THE 7th THE 8th THE 9th THE 10th
WILL COME

THE 11th AND THE 12th
WILL SPEAK, WHAT NEWS WILL
THEY BRING, GOOD OR BAD
WHAT WILL IT BE FIRST
THE 1RST OR dE 2nd

OR WILL IT BE 3 IN 1

3/7 7

$18 \times 5 = 90$
10
100

18 COBICS

X 18

SANTA
TRUTH
WAY
1 2 3

LIETH
MARIA

19 = 10th
20

WINDOW
31 903
31 4 903
20

36 = 11

WINDOW

ALL 3 IN JESUS → 1 CHRIST

3

3

FAJER
SONER
MODER

LEGION OF 300
VS
ARMY OF 3000

SOME SAID, God KILL 3000 IN ONE dAY
I SAId God KILL NO ONE IN ONE dAY
IT WAS AN ARMY OF 3000 ATTAKING
A CITY ANd 300 dEFENdERS FIGTHING
FOR SELF dE,FENCE, ANd SURVIVAL, OF
THEIR CHILdREN WIFES ANd CITY

THE RIGTH AND THE WRONG

```
      RIGTH³              WRONG⁷
     ↓↓↓↓↓               ↓↓↓↓↓
     9 1 9 I I           3 9 0 N 9
     ↓↓↓↓↓               ↓↓↓↓↓
     9,1,9 I I           3,9 0 4 9
     +++++               +++++
      ‗                   ‗
     2,'1                2,5
     ↓                   ↓
     3                   7 = EVIL
                           ↓↓↓↓
                           3 N 1 7
                           ↓↓↓↓
                           3,5,1,7
                           +++
                           ‗
                           1,6
                           ↓
                           7
```

IF God GIVES LIFE
HE IN,TENTHS FOR THAT LIFE
TO LIVE TO AN OLd AGE, IT IS EVIL
MEN WHO CUTS LIFE SHORT.
A LIGION JOLdIER IS A HERO
AN ARMY SOLdIER IS AN ASÁSIN
A LIGION SOLdIER CRYS WHEN HE IS PUT IN
A POCISION OF SECF DEFENCE,
AN ARMY JOLdIER REJOYS IN HIS KILLINGS

129

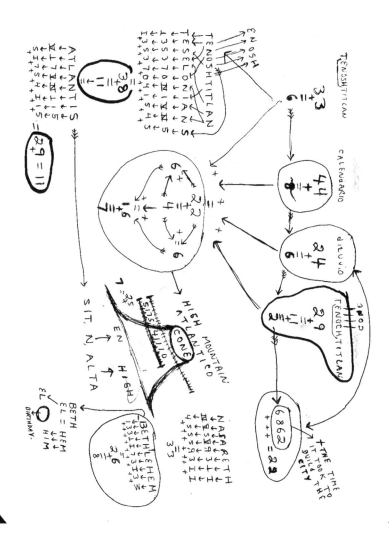

131

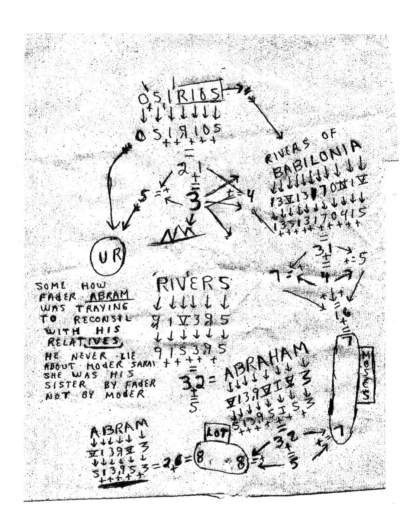

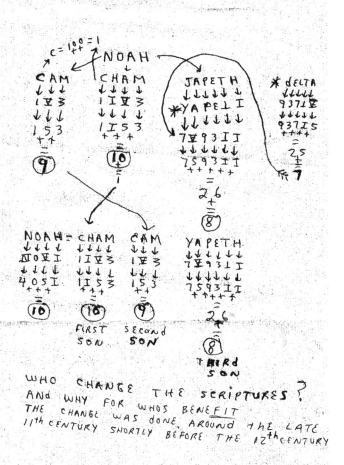

WHO CHANGE THE SCRIPTURES? AND WHY FOR WHOS BENEFIT THE CHANGE WAS DONE AROUND THE LATE 11th CENTURY SHORTLY BEFORE THE 12th CENTURY

MOSES FULL NAME

HILIBERTO dE MOSES
I 7 19 39 1 0 9 3 3 0 5 3 5
I 1 7 19 39 1 0 12 16
3 2 3 → + → 7 = 10
ONE TABLET S

C = 100 = 1
U
R
9
+
10

= ABRAHAM
V 13 9 1 1 3
5 13 9 5 1 5 3
3 2

SECOND TABLET → S = 10 = (20)

+

HEBREW = ← HEBREO
I 3 1 3 9 33 I 3 1 3 9 3 0
23 = S 20 = HOMBRE
 I 0 3 13 9 3
COMANDMENTS 10 = + 40 20
 ← S = 23 YEARS IN THE
 DESERT
EGIPTO
3 9 1 9 1 0
3 9 1 9 I 0

134

CHAPTE 4
PART 2
LENGUAGES

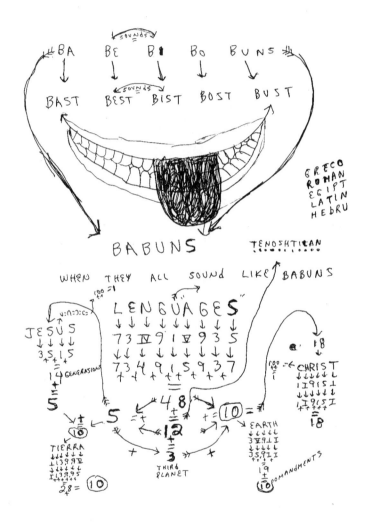

BABUNS

WHEN THEY ALL SOUND LIKE BABUNS

LOSS BOOT ONES THE LAW ⬛ bLVES
SAKE TWO U.S ABBAS iKE POCK COAP
POCK CODES A boot ON ABBAS
GENE ME THIO THE TO do ME.

IF I SPEAK OF THE COWBOYS
WHO WERE THE FOUNDING FATHERS
OF AMERICA, THEY SPEAK
ABOUT A butlers

LOS BOTONES dE LA BLUSA QUE
TU USABAS Y QUE POCO A POCO
dESABOTONABAS Y EN MEDIO dE TOdO
ME. dEJADAN VER UN POCO dE TI

FUSION OF LENGUAGES

WHATS WORONG WITH THEIR
"EARS"

THEY SAY SPEAK INGLISH ANd
YET THEY SPEAK SPANISH

0,01 =⁊ ← eATORCE
↓↓ ↓↓↓ ↓↓
1 Ⅳ⊥09 1 3
↓↓ ↓ ↓ ↓ ↓ ↓
1,5 Ⅰ,9,9,13
+ + + + + +
20 = SEAL
↓↓ ↓ ↓↓↓
5, 3 ≠7
↓↓↓↓↓
5,5,5,+
40 =⊱← 5,+,+,+
20

ANdRES =
↓ ↓ ↓ ↓ ↓ ↓
Ⅴ Ⅳ 9 9 3 5
↓ ↓ ↓ ↓ ↓ ↓
5 4 9 9 3 5
+ + + + +
=
3+5
=
8

ANdREW
↓ ↓ ↓ ↓
Ⅴ Ⅳ 9 9 3 3
↓ ↓ ↓ ↓
5 9 9 3 3
+ + + +
= 3

$x = 40 =$ diSiPLES
↓ ↓ ↓ ↓ ↓ ↓ ↓
9 1 5 1 9 7 3 5
+ + + + + +
40

11 = + INFINITY +

#ELEVEN + 50

LOS BOTONES DE LA BLUSA QUE TU
USABAS Y QUE POCO A POCO DES,A BOTON
ABBAS Y UN POCO COMFUSA ME
DEJABAN VER, EN MEDIO DE TODO
UN POCO DE TI, BOCAS QUE MURMURAN
BOCAS QUE SE BESAN, BRASOS QUE SE
ABRASAN,

EL,EVEN = ARIEL
↓ ↓ ↓ ↓ ↓ ↓ ↓ ↓ ↓ ↓ ↓
3 7 3 Ⅴ 3 Ⅳ Ⅴ Ⅷ 1 3 7
↓ ↓ ↓ ↓ ↓ ↓ ↓ ↓ ↓ ↓ ↓
3 7 3 5 3 4 5 9 1 3 7
+ + + + + + + + + + +
= =
2 5 2 5
9 = + = 1 2 9 = + = 1 2
7 7
16 10 3 16 10 3

SÜN TSI NAN WA

TOH JUH MR. LI

HTRON A390>I

LI ENO

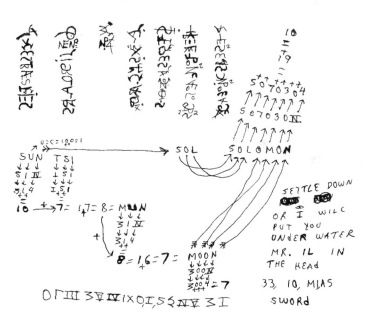

SOL SOLOMON

SUN TSI

SETTLE DOWN
OR I WILL
PUT YOU
UNDER WATER
MR. IL IN
THE HEAD

33, 10, MIAS
SWORD

139

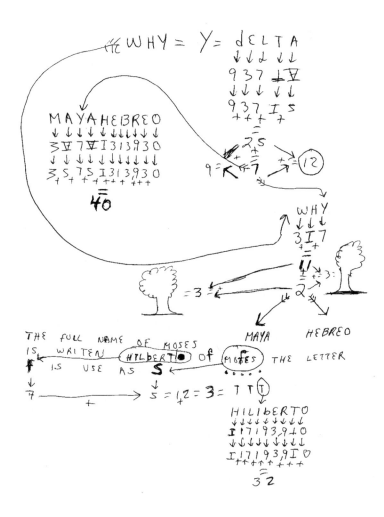

THE WHY = Y = dELTA
↓ ↓ d ↓ ↓
9 3 7 ⊥ ⅣⅤ
↓ ↓ ↓ ↓ ↓
9 3 7 I S
+ + + + +

MAYAHEBREO
↓ ↓ ↓ ↓ ↓ ↓↓↓ ↓ ↓
3 Ⅴ 7 Ⅴ I 3 1 3 9 3 0
↓ ↓ ↓ ↓ ↓ ↓↓↓ ↓ ↓
3 S 7 S 1 3 1 3 9 3 0
+ + + + + + + + + +
=40

9 = K + 7 + = 12

WHY
↓ ↓ ↓
3 I 7
+
Ⅱ
2 + = 3:
= 3

THE FULL NAME OF MOSES MAYA HEBREO
IS WRITEN HILbERTO● OF MOSES THE LETTER
F IS USE AS S

↓
7 ————→ 5 = 12 = 3 = T T(T)
 +

HILIBERTO
↓↓↓↓↓ ↓↓↓
I17193,940
↓↓↓↓↓ ↓↓↓
I17193,9I0
+++++ + ++
=32

140

TO TH.EY

NO ME COMPLUSEE, QUE LOSS HOMBRES DEL
PRE,SENT, SEEK ON PAR EN CON LOS HOMBRES DEL
PASADO, Y VAYAN PRE,GONE AND DO LOCKE NO
SAVEN, COMO PUEDE UN HOMBRE DECIR AHORA
LOCKE ACONTE SEE OH EL DIA QUE JESUSCHRISTO LE
LAVA SE LOS PIES A PETER, Y COMO PODER DES IR
[EAR] QUE PETER NO COMPREN DIOS3 LOCKE ESE
THIA SEE LEE DI,JOSE, COMO VOS PODER PRE SUM
EAR, SAVER MASS QUE UNO QUE CON EL SENOR
CAMINASE, Y MAN DASE EL MENS AGE PARA LA
POSTE RIOR Y DAD, PARA QUE YO LO CUP TASE Y
AVOS DI,JESSE QUE NO WHOS GASE A LOS QUE A
VOS JUSGARON EN EL PAS [A] DO, VOS KEY SEE ERA
QUE EL NOMBRE DE PETER SABOR RACE THEL LIBRO
DE LA VID DA, Y QUE EL VUESTRO SEA GREE GASE,

MASS VOS PRE GONE ASE Y COBRAS POOR LOW QUE
VOS AS SEES, VUES,TRAP,AL ABRA NO MEEK ON
PLUS SEE, VUESTRO PREGONARE......IS...WEAK,

SHARP PEN ARE SENIORE SUP AL ABRA Y VOS
ACCIONES LOCK CASTIGA Y LOCK ON DEEN AH, NO

1: I don't know what collage you went to or how much you paid but you got robed

2: I don't know what seminari you went to or how much you paid but you got Robed

3: I don't know what law scholl you went to or how much you paid but you got Robed

Robed
↓↓↓↓↓
9.0.9.3.9
+ + + + +
=
30

SOME BODY SACK YOU BIG TIME

I RECOMEND, YOU TO GO TO THIS

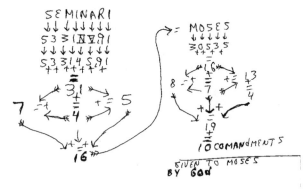

SEMINARI
↓↓ ↓↓↓↓↓
5 3 3 | ₦ ⩊ 9 |
↓↓↓↓↓↓↓↓
5 3 3 1 4 5 9 1
+ + + + + + + +
=
3 1
+
4
= 5

7

↓
+ +
16

= MOSES
↓↓↓↓↓
3 0 5 3 5
+ + + +
=
1 6
=
7
+
1 9
+

8

= 1 3
4

10 COMANDMENTS

GIVEN TO MOSES
BY GOD

bUT NEVER THE LESS WHEREVER
COLLAGE SEMINARI OR SCHOLL
EVERY BODY GET A GRADUATION
dIPLOMA OF HOW TO APPLY
WHAT THEY LEARN,
EVERY BODY ROBED EVERY BODY

ROBED
↓↓↓↓
90939
++++
‾‾
30

I GESS I SHOULD HAVE NOT
TURN THAT KEY OF THE
OLD "ROPERO" WHERE HIDALGO HId
↓↓↓ ↓↓↓↓↓↓
079 909390
+++ ++++++
‾‾‾ ‾‾‾‾‾‾
16 30 ALL HIS SEEK CREETS
+

← 7 JULY 30 1811. →

SI AS DE TENER UNA ROSA YOU MAST FEEL THE
TORNS
IF YOU NEVER KNOW ABOUT PAIN YOU WILL
NEVER KNOW ABOUT HAPPINES

AND AS THIS CUP PAS ES
FROM ME I SAY ON TO
YOU, MY WAY IS JESUSCHRIST
WAY, NOW YOU GO ON YOUR
WAY, AND I GO MY WAY
↓↓↓
MAY THE MERCY YOU GIVE TO
OTHERS YOU ALSO RECIEVE

MAY HOW YOU BLESS OTHERS YOU
ALSO BE BLESS

MAY HOW YOU TAKE FROM OTHERS
OTHERS TAKE FROM YOU ALSO
MAY HOW YOU PRAY ON OTHERS
OTHERS PREY ON YOU ALSO

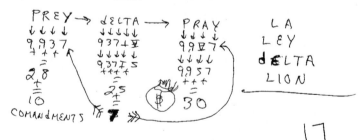

17

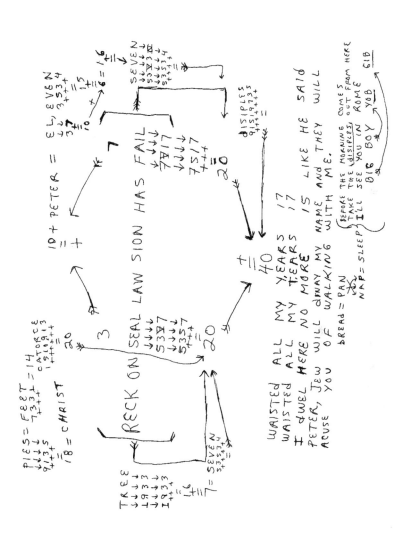

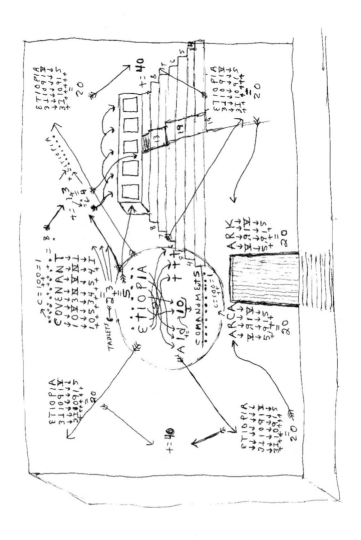

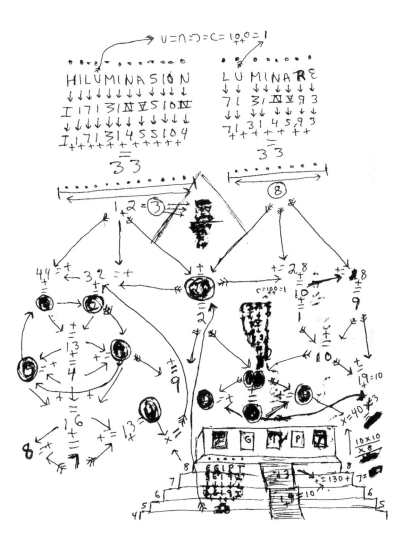

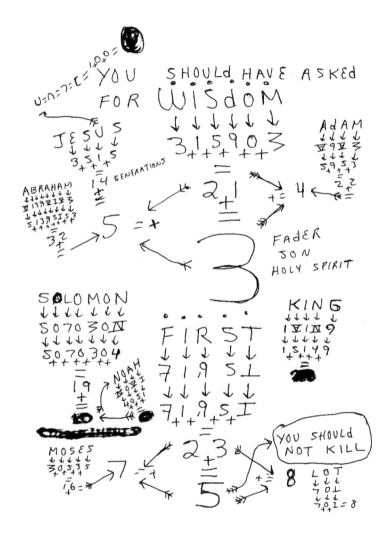

148

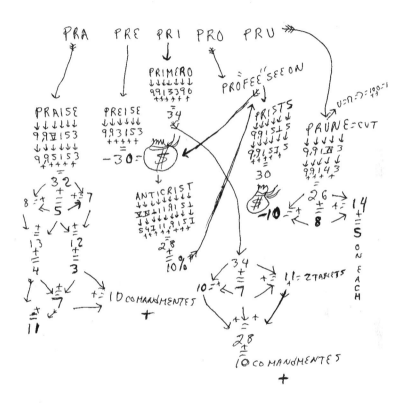

WHEREVER NEGATIVE HERE WRITEN TAKE IT +

WHY FAILURE ON THE LAST
STEP

VENUS
5⊥39
5⊥39
53415
=
18

18 TO REACH CHRIST

SUN
5 I Ⅳ
5I4
=
10

2,8 = +
=
10

10

c = 100 = 1 c = 100 = 1

93Ⅹ(I (I,9,5I
935(I 1,1,9,5I
= +
19 18
10 += 2,8 = 10

6/5
JUNE FIVE 2,0,1,2 AT 10:30 AND 11:00 O'CLOCK
5

ONLY 1 2,3 = H E S U S

S,X,V,E,S = J E S U S

YOU ALMOST MADE IT TO
THE TOP BUT ON THE
LAST STEP YOU
SAID THIS

AND YOU SAID
WE ARE THE LIGTH
WE ARE THE TROTH
WE ARE THE WAY

YOU HAVE
FAIL

8

7 7

6 16→ MOSES 6
5 30,5,25 5
4 = 4
3 NOAH POOR REPRESENTASION OF GOD 16 3
2 ABRAHAM POOR REPRESENTASION OF GOD 2
1 PETER POOR REPRESENTASION OF GOD 1
 MOSES POOR REPRESENTASION OF GOD

THOSE WHO PUT THEIR SELFS IN TEMPLES
AND CLAIM TO BE THE SAVIORS OF THE
WORLD AND YET THE WORLD IS NOT SAVE
"IT YET COULD BE SAVE"

YOU SAID WHAT YOU
SAID AND IS RECORDED
IN THE BOOK OF LIFE

150

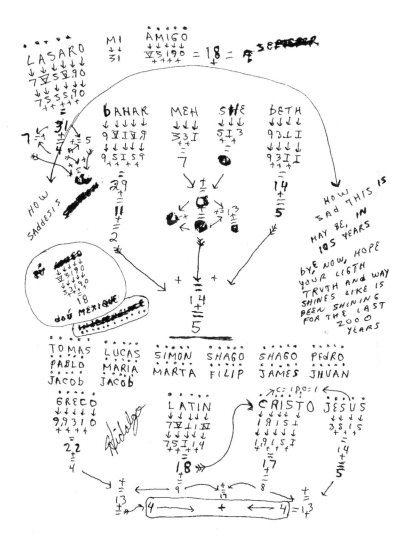

151

AMIGO

dEER FRIEND OF MY YAQUI SON
OF SONORA SINCE THE dAY YOU
CAME IN TO MY LIFE, IN EVERY
JOURNEY, IN bAd TIMES, IN GOOd
TIMES YOU ALL WAYS STOOd BY ME
ANd HOW EXTRANGE OUR LIFES CAME
TO,GET,HERE, MY dEER MR. RIV,ERA

IF I COULd FINd 1000,000 LIKE YOU OR
LIKE THE COUNT OF PAREdES

CHARLES SMITH

HOMBRE DE ALTA ESCUELA HOMBRE DE
PORTE FINO QUE CAMINA ENTRE LA POBRESA
HOMBRE RICO, ME SORPRENdE TU NOBLESA
DONDE PODRE ENCONTRAR AMIGOS QUE
TENGAN TU GENTILESA.
dONdE PODRE ENCONTRAR 1000,000 dE
GENTILES

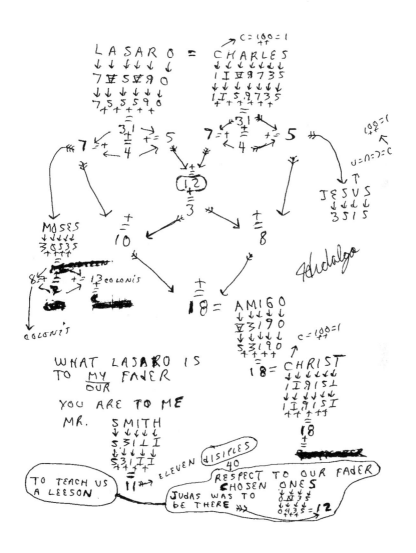

$1+2=$ ③

MEMORIAL dAY

THE PEOPLE OF ALL NATIONS
SAYS "GOd BLESS OUR TROPS

BLES SEED THEY ARE
THEIR SEED GROWS NO MORE.
HOW THEY BLESS OTHERS
SO THEY WILL BE BLESS
HOW THEY GIVE MERCY TO OTHERS
SO THAT MERCY THEY SHALL RECIEVE
AS FOR I KNOW THIS

YOU SHALL NOT KILL

154

5/20/2012 → ITALIA
EARTHQUAKE

REMEMBER POMPEI →

.79
−33
46 = 10

2012
− 79
1933
+ + +
=
16
+
=
7 SUNDAY
MONDAY
↓ ECLIPSE

EARTH
↓ ↓ ↓ ↓
3 9
↓ ↓ ↓ ↓
3 5 9
+ + +
=
10

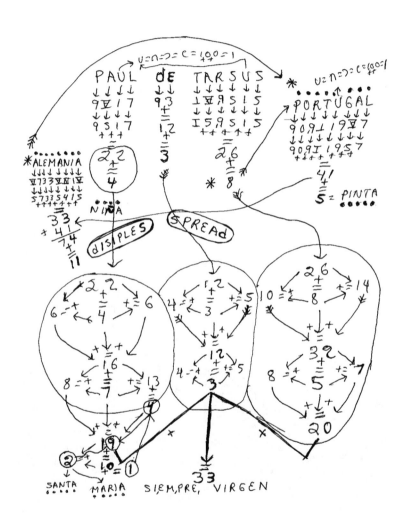

156

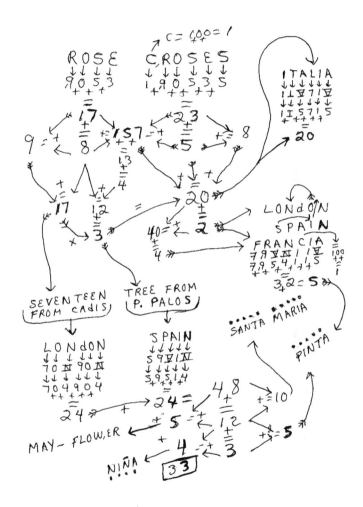

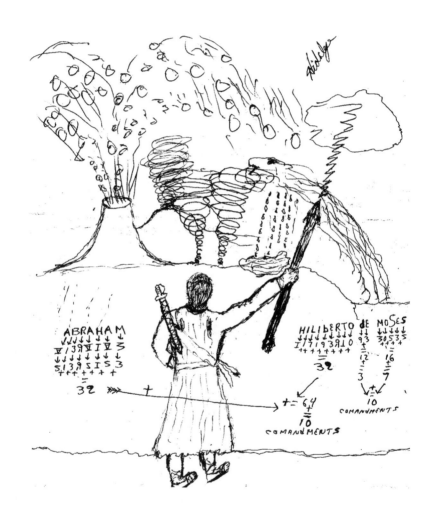

CHAPTER 5

HidALGO
↓↓↓↓↓ ↓↓
I 19Ⅴ79 0
↓↓↓↓↓↓ ↓
I 1 9 5 7 9 0
+++++++
＝
3 2
COLONIS → 8 ← + → ↓ ← 7
← 5 +=

↓ + ↓ ↓ + ↓
COLONIS → 3 ＝ 12 ＝ 5
← + ＝ += ＝ ← += ＝ → ↓ c=100=1
5 ← 4 → 7 4 ← 3 → 8 COLONIS
↓ + ↓ + JULY FOURTH → + ↓↓↓↓↓ ↓
＝ 8 1 0 7 0 Ⅸ 5
16 1 0 7 0 4 ↓↓↓↓↓ ↓
dIESISEIS 1 0 7 0 4 5
+++++++
dE SEPTIEMBRE 9 ＝
18

159

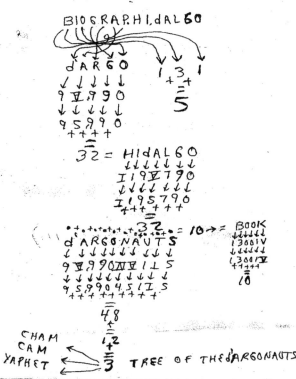

BIOGRAPH.HI.dAL 60

d ARGO 1 3 1
9 V 9 90 + = +
9 5 9 9 0 5
+ + + +
= =
32 = HIdALGO
I 1 9 V 7 9 0
I 1 9 5 7 9 0
+ + + + +
= =
32 = 10 → = BOOK
d ARGONAUTS 1 300 1 V
9 V 9 90 V V 1 L 5 1 300 1 V
9 5 9 90 4 5 1 I S 1 300 1 V
+ + + + + + + + + + + +
= = = =
4 8 1 0
+ =
1 2
CHAM + =
CAM 3 TREE OF THE d ARGONAUTS
YAPHET

161

TREATY OF GUADALUPE HIDALGO

2006

WYOMING

WYOM,IN,G
E
T
A

dELTA
↓ ↓ ↓ ↓ ↓
9 3 7 ± V
↓ ↓ ↓ ↓ ↓
9 3 7 I 5
+ + + +
=
2 5
±
=
7 =

WYOMING
↓ ↓ ↓ ↓ ↓ ↓
3 7 0 3 1 IV 9
↓ ↓ ↓ ↓ ↓ ↓
3 7 0 3 1 4 9
+ + + + + +
=
2 7
+

SIXTEEN

11 =
+
SEPTEMBER
COLONIS → 8 =
+
13 → COLONIS
+
=
JULY
FOURTH

169

did YOU KNOW THAT THE AMERICAN
FLAG WAS MADE IN MEXICO BY A
MEXICAN MEN NAME MIGUEL HIDALGO
AND IT WAS coded AS FALL LOW

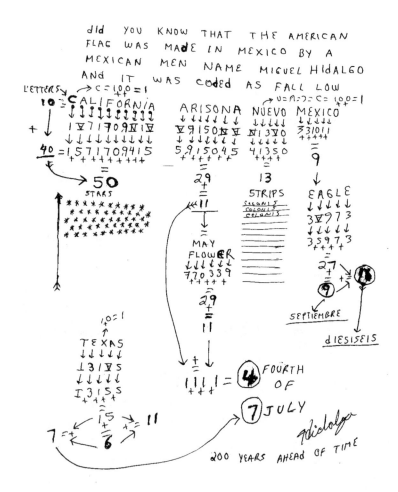

LETTERS → c = 100 = 1
10 = CALIFORNIA
↓↓↓↓↓↓↓↓↓↓
+ ↓ 1 ▼ 7 1 7 0 9 N 1 ▼
40 = ↓↓↓↓↓↓↓↓↓↓
= 1 5 7 1 7 0 9 4 1 5
+++++++++
=
50
STARS

v = n = 2 = c = 100 = 1

ARISONA NUEVO MEXICO
↓↓↓↓↓↓↓ ↓↓↓↓↓
▼ 9 1 5 0 N ▼ N 1 3 ▼ 0 3 3 1 0 1 1
↓↓↓↓↓↓↓ ↓↓↓↓ ++++
5.9 1 5 0 4 5 4 1 3 5 0 9
++++++++ +++ ↓
=
29 13 EAGLE
+ STRIPS ↓↓↓↓↓
11 COLONIS 3 ▼ 9 7 3
↓ COLONIS ↓↓↓↓↓
MAY COLONIS 3 5 9 7 3
FLOWER +++
↓↓↓↓↓ =
7 7 0 3 3 9 27
+++++ +
= 9
29
+ SEPTIEMBRE
11
diesiseis

TEXAS
↓↓↓↓↓
⊥ 3 1 ▼ S
↓↓↓↓↓
I 3 1 5 S
+++
=
15
+

100 = 1

±
↓
1 1 1 1 = 4 FOURTH
+++ OF
7 JULY

7 = ← 6 → = 11

200 YEARS AHEAD OF TIME

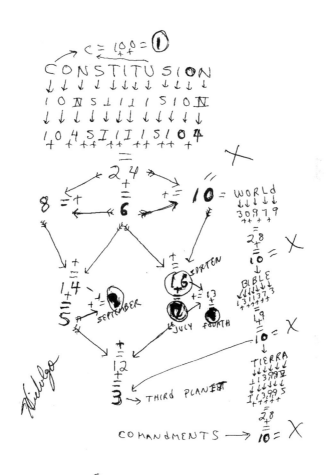

did YOU KNOW THAT THE (COLORS)
OF THE AMERICAN FLAG WERE CHOSEN
BY A MEXICAN NAME
 MIGUEL HIDALGO COST,ILLA

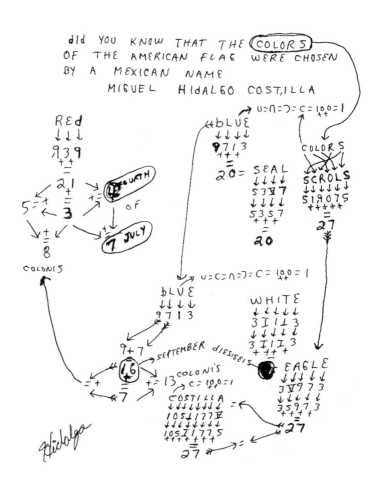

COLONIS

Hidalgo

YO NO SOY SU PEN,DEJO A MI NO
ME VENDAN LOS OJOS

C = 10,0 = 1

IGNACIO SARAGOSA MAY FIFTH
19 ... 110 5 ... 905 5 ± S
1945110 53,959055
 Hidalgo

5 = ± 21 ± 3 4 11 = ± 4 3 ± 10

± 13

U ⊃ ∩ ⊃ ⊃ = C = 100 = 1

GUADALUPE
9 ... 9 ... 193
9159 57193

±7 = ±

MASON 49
3 ... 50 5 = ± ± = 12
3550 4 13 ± 3 5

17 LORETO
 70,93 ⊥ 0 FOURTH 7 ± 12
 70,93 I,0 3
20 9 JULY
 SEPTIEMBRE
 16
 DIESISEIS

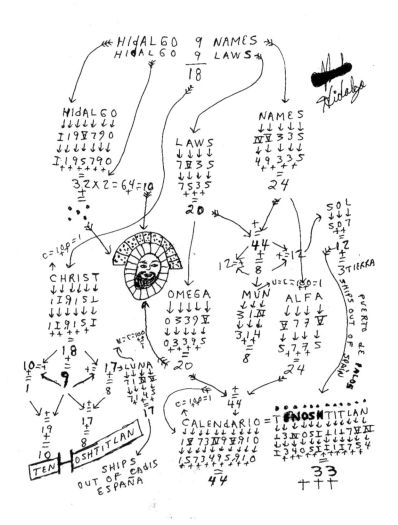

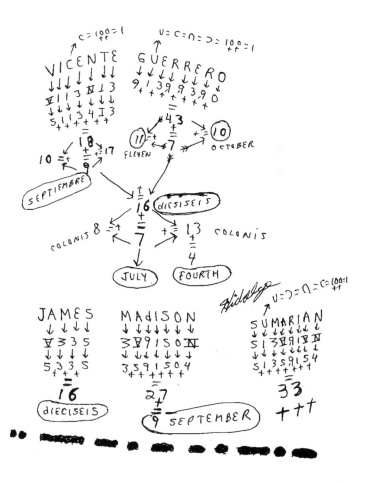

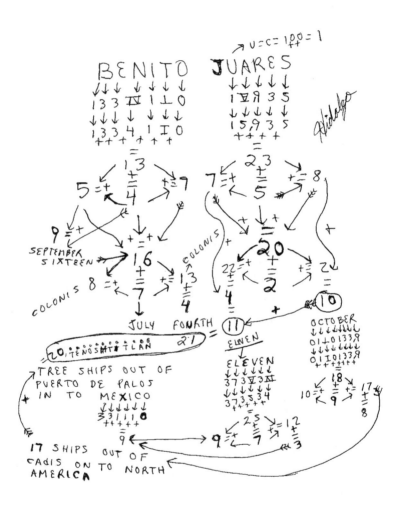

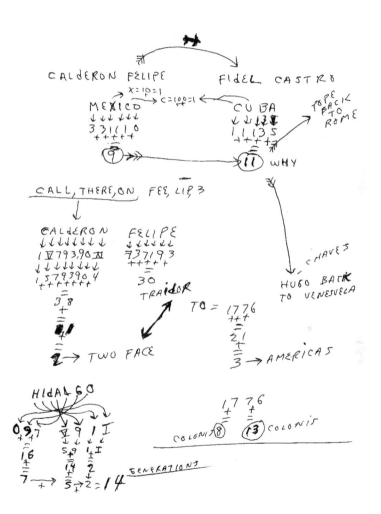

CALDERON FELIPE FIDEL CASTRO

MEXICO x=10=1
↓ ↓↓ ↓↓↓ c=100=1 ← CUBA POPE
3 3 1 (1 0 ↓ ↓↓ ↓↓↓ BACK
+ + + + + 1 1 1 3 5 TO
 ⑨ →→→ + + + + ROME
 ⑪ WHY

CALL, THERE, ON FEE, LIP, 3

CALDERON FELIPE
↓↓↓↓↓↓↓ ↓↓↓↓↓↓
1 Ⅴ 793,90 Ⅺ 7 3 7 1 9 3
↓↓↓↓↓↓↓ + + + + +
1 5 7 9 3 9 0 4 30
+ + + + + + + TRAIDOR
 3 8 CHAVES
 + TO = 1776
 4 ↗ + + + HUGO BACK
 ↙ 2 1 TO VENESUELA
 2 → TWO FACE 3 → AMERICAS

HIDALGO
 1 7 7 6
0 9 7 Ⅴ 9 1 Ⅰ + +
+ + + COLONI ⑧ ⑬ COLONIS
1 6 5 9 1 Ⅰ
7 → 4 2
 + 3 → 2 = 14 GENERATIONS

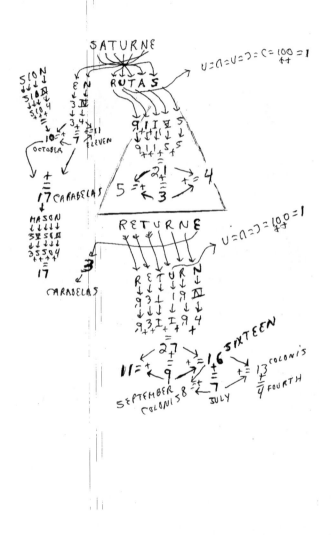

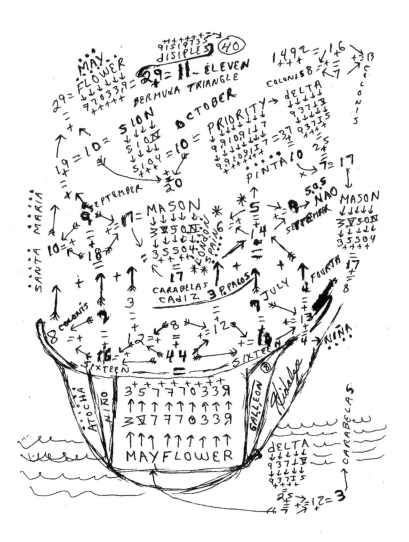

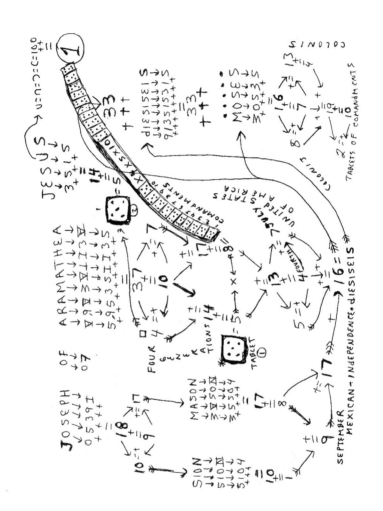

180

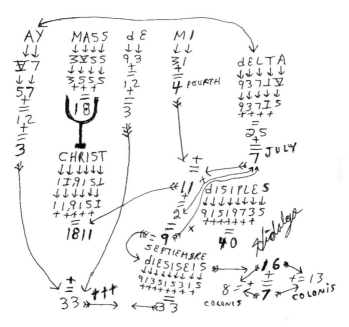

AY MASS d ε MI dELTA
↓↓ ↓↓↓↓ ↓↓ ↓↓ ↓↓↓↓↓
Ⅴ7 3Ⅴ55 9.3 3̄⁄1̄ 937ⅡⅤ
↓↓ ↓↓↓↓ +̄⁄+̄ =̄ ↓↓↓↓↓
5̄7̄ 3̄5̄5̄5̄ 1̄2̄ 4 FOURTH 937Ⅰ5
+̄⁄+̄ +̄+̄+̄ =̄ +̄+̄+̄+̄
=̄ 18 3̄ 2̄5̄
3̄ +̄⁄+̄
 CHRIST 7 JULY
 ↓↓↓↓↓↓
 ⅠⅡ915Ⅰ ≠̄11
 ↓↓↓↓↓ =̄ dISIPLES
 11,915Ⅰ 2̄1 ↓↓↓↓↓↓↓
 +̄+̄+̄+̄+̄ 91519735
 1811 +̄+̄+̄+̄+̄+̄
 ≠̄=̄9̄ × =̄
 SEPTIEMBRE 4̄0 Hidalgo
 dIESISEIS ⇒ ★16★
 ↓↓↓↓↓↓↓↓
 91351531̄5 8=+̄ +̄=13
 +̄ +̄+̄+̄+̄+̄+̄ ⟵7̄ COLONIS
 =̄ COLONIS
 33 ⇒⇒ ⇒ ⟵3̄3̄ COLONIS

 QUIEN dARA LUS A MIS OJOS
 Y QUIEN HECHARA AGUA A MI CABESA

 HIdALGO LETTER OF RETRAC "SION"
 ↓↓↓↓↓↓ ↓↓↓↓↓ ↓↓↓↓
 Ⅰ19Ⅴ790 731139 SION
 ↓↓↓↓↓↓ ↓↓↓↓↓ ↓↓↓↓
 Ⅰ195790 731139 5104
 +̄+̄+̄+̄+̄+̄ +̄+̄+̄+̄ =̄
 =̄ 24 10=X
 32 CARTER
 ↓↓↓↓↓↓
 ⅠⅤ91139
 ↓↓↓↓↓↓
 159Ⅰ39
 +̄+̄+̄+̄+̄
 2̄+̄8 =10=X FILES

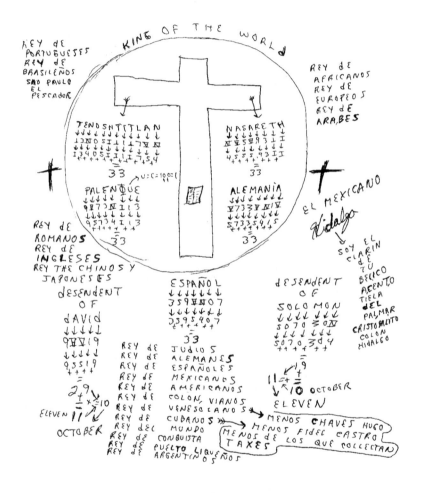

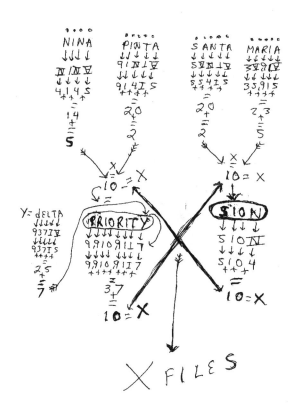

X FILES

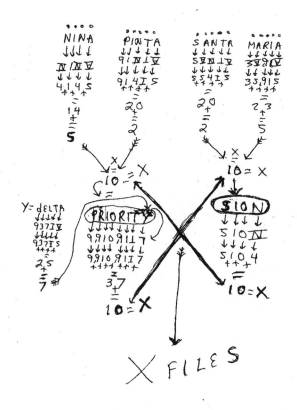

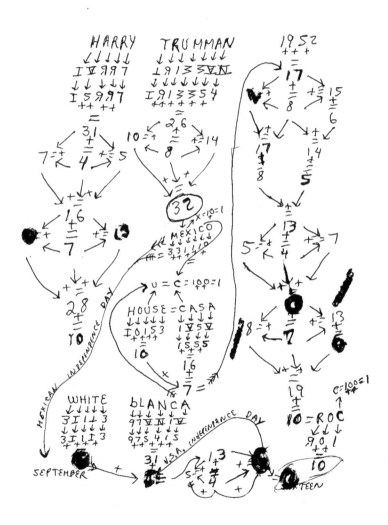

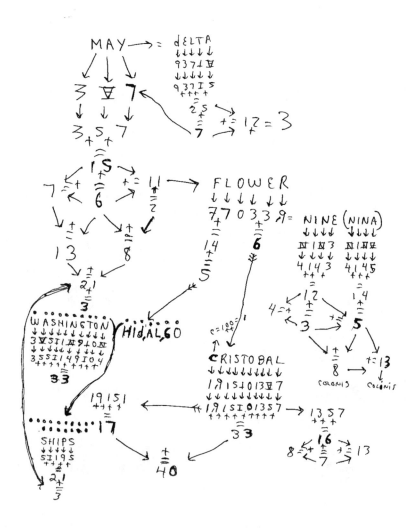

4-27-2012

POR MEdIO DE LA "PRESENTE" A GO SAVER
A LOSS CANJY, JATOS A LA PRESIDENCIA
DE MEXICO, GRACIAS POR SU PARTICIPA
"SION" EN LA CONTIENDA

dESDE EL PRINCIPIO DE LA
FUN, THVS, SION DE MEXICO ESTA
ESCRITO QUE ALGUN DIA VENdRIA YO
A RECLAMAR LO QUE SE ME DEJO
DESDE ANTES QUE YO VINIERA AL MUNdO
LAS MARCAS DEJADAS POR EL PADRE DE
LA INDEPENDENCIA ESTAN A MI NOMBRE
NO LAS ENCONTRARAS EN PAPEL SINO
EN LA TIERRA.
EMPECEMOS CON MI CAMA LA CUAL FUE MI
CUNA.

→ C = 100 = 1
CAMAR6O
1 Y 3 Z 9 9 O
1,5 3 5,9 9 O
───
3 2

→ SIGAMOS CON LA CAMPANA →
→ C = 100 = 1
1 Z 3 9 Z Z Z
1,5 3 9 5 4 5
───
3 2

CONTINUEMOS CON MI APELATIVO Y MIS
PRIMEROS PADRES DESPUES DEL DILUVIO. Y ANTES

ABRAHAM
Z 13,9 Z I Y 3
5 13,9,5,I 5 3
───
3 2

JESUSCHRISTO
3 5 I S I I 9 I 5 1 O
3,5 I S I I 9 I 5 I O
───
3 2

HIdAL6O
1 I 9 Z 7 9 O
I 1 9 5 7 9 O
───
3 2

*C = U *
U : N : ⊃ = 100

Hidalgo

ATTE: EL ANGEL DE LA INDEPENDENCIA

4/28/2012

ATENTAR CONTRA LOS HIJOS DE DIOS
ES ATENTAR CONTRA EL MISMO TODOPODEROSO
CREADOR DEL UNIVERSO. (SEMBRARON VIENTOS Y
HOY COSECHAN
TEN, PEST, HADES)

(7/30/1811)

ALDAMA ALLENDE JIMENES
↓↓↓↓↓↓ ↓↓↓↓↓↓↓ ↓↓↓↓↓↓
Ⅺ79Ⅴ3Ⅴ Ⅹ773Ⅳ93 133Ⅳ35
↓↓↓↓↓↓ ↓↓↓↓↓↓↓ ↓↓↓↓↓↓
579535 5773493 133435
+++++ +++++++ +++++++
 = = =
 3,4 3,8 1,9
 = = =
 + + +
 7→ + →11 ⟫ + →10 = 28 = AGUILA
 = ↓↓↓↓↓↓
 2 Ⅺ9117Ⅴ
 ↓↓↓↓↓↓
 ESCUDO NASIONÁL 591175
 ++++++
 28

 U=∩=⊃=(=100
 =
 1

NO "VENGÓ" EN "SON" DE GUERRA
 VENGO EN SON DE PAS
 VENGO A LIMPIAR LA SAL Y MAÑAS
 ↓↓ ↓↓↓
DE LA MAN, "SION" LAS ALIMAÑAS
AN CONVERTIDO LA CASA DE MIS PADRES
EN UNA MANSION DE ASESINOS Y LADRONES
QUE SE JACTAN DEL DOLOR AJENO
TIEMPO, MI MEJOR ALIADO
SILENCIO MI MEJOR AMIGO Hidalgo
 200 AÑOS ES MAS QUE SUFICIENTE PARA
 LEVANTAR EL CAST, Y, GO, AL SON, Y, do, DE CAMPANA

JERUSALEN LE CERRO LAS PUERTAS
A MI PADRE EN SU VENIDA Y
NASARETH SE LAS ABRIO

↓↓ ↓↓↓↓↓↓
N∀S∀A3⊥I
↓ ↓↓↓ ↓↓↓
4,5 5 5,9 3 I I
+ + + + + + +
$$\overline{\overline{33}}$$

✝✝✝

→ NUEVA JERUSALEN →

NO POR QUE YO LO DIG,A
SI NO PORQUE ES EL
PUEBLO QUE EN
DOLORES LO dES,PI,d IO
↓↓↓↓ ↓↓↓
9 0 7 0 ,9 3 5
+ + + + + + +
$$\overline{\overline{33}} \rightarrow ✝✝✝$$ *Hidalgo*

TIEMPO MI MEJOR ALIADO
SILENCIO MI MEJOR AMIGO
2 000 AÑOS DE CAST Y GO, ES MAS
QUE SUFICIENTE PARA LEVANTAR
EL CASTIGO

SU PUEBLO QUERIDO QUE MI PADRE
TANTO AMO
 JESUS OF NASARETH
I COME IN HIS NAME NOT AS FOR
HE ,SAID MANY WILL COME IN MY NAME
DON'T FALLOW THEM, THEY ARE FALSE.
THERE FOR I COME IN THE NAME THAT
I WAS GIVEN BEFORE I WAS BORN. ? ㊵

189

(40) MISTERY NUMBER

40 dAYS OF RAIN IN THE TIME OF MY

FADER NOAH

↓↓↓↓↓
7Ⅱ939
↓↓↓↓↓
75939
+ + + +
==
33 †††

Hidalgo

40 YEARS OF FADER MOSES IN THE deSERT.

40 YEARS OF FADER dAbid AS KING

↓↓↓↓↓ ↓↓↓↓↓
7Ⅱ939 9Ⅴ919
↓↓↓↓↓ ↓↓↓↓↓
7Ⅱ93,9 9,5919
+ + + + + + + +
††† == 33 == 33 †††

40← dAYS TO THE ↓disiplES AFTER RESURECTION

↓↓↓↓↓↓↓↓
91519775
+++ ++++
==

c=10,0=1 →40 U = c = 10,0 = 1

SOMBRERETE CRAdLE SUMARIAN LENGUAGE"
↓↓↓↓↓↓↓↓ ↓↓↓↓↓↓ ↓↓↓↓↓↓↓↓
50 3139393Ⅰ3 1Ⅱ973 SI 3Ⅴ91Ⅴ Ⅱ
↓↓↓↓↓↓↓↓↓↓ ↓↓↓↓↓↓ ↓↓↓↓↓↓↓↓
503139393Ⅰ3 195973 SI 35,9154
+ ++++ + + ++ + + == + + + + + + == + + +

== 40 ← == 7 + == 33 → † † †
40← 3,4
↓

MI NOMBRE EN MAY, US, COOL, LAWS,
 ⎣MAYUSCULAS⎦
 IN HEBRON IN JERUSALEN
 ← MY WORD IS KING →

190

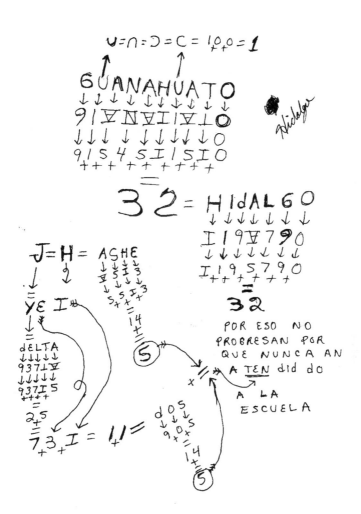

$$U = \cap = \supset = C = |_{+}0_{+}0 = 1$$

6UANAHUATO

9 I Ɐ Ɐ I Ɐ I Ɐ O

9 I S 4 S I I S I O

$\overline{32}$ = HIdAL6O

I I 9 Ɐ 7 9 O

I I 9 5 7 9 O

$\overline{32}$

POR ESO NO
PROBRESAN POR
QUE NUNCA AN
A <u>TEN</u> did do
A LA
ESCUELA

J = H = ASHE

Ɐ 5 I 3

5 5 I 3

14

(5)

YE I

dELTA
937 I Ɐ
937 I 5
2 5

73 I = 1 I = dOS
9 O S
14

(5)

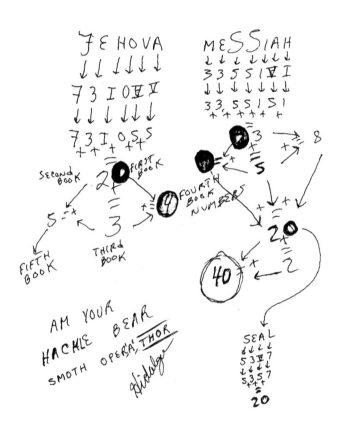

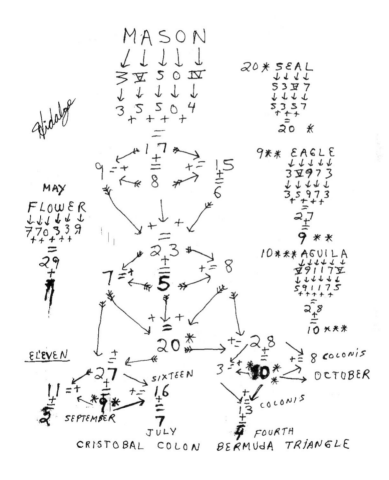

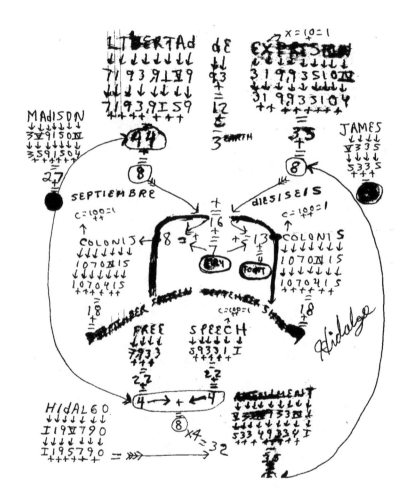

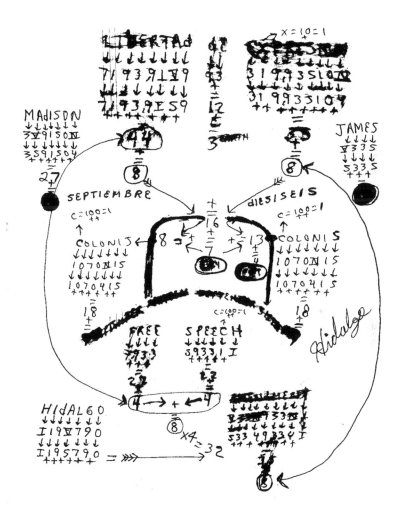

. SENd ME A bILL I'L "SIGN" IT 2 MORE ROW

GEORGE WASHINGTON
↓↓↓↓↓↓ ↓ ↓ ↓↓↓↓ ↓↓↓
9 3 0 9 9 3 3 ⅤSIⅢ9↓0Ⅳ
+ + + + + + ↓ ↓ ↓↓↓↓ ↓↓↓
 = 3 S SI149I04
 33 + + + + + + + +
 =
 33

𝓗𝒾𝒹𝒶𝓁𝑔𝑒
HERNAN 1519
CRISTOBAL 1492
 0027

 ↓±
 ↓=
 66 → BOOKS OF THE BIBLE
 ↓±
 ↓=
C=100=1 12
 ++ ↓±
 ↓=

CRISTOBAL HIdALGO COSTILLA C=100=1
↓↓↓↓↓↓↓↓↓ ↓↓↓↓↓↓↓ ↓↓↓↓↓↓↓↓ ++
19151013Ⅴ7 I19Ⅴ790 105⊥177Ⅴ
↓↓↓↓↓↓↓↓↓ ↓↓↓↓↓↓↓ ↓↓↓↓↓↓↓↓
19151013S7 I195790 105I1775
+++++ +++++ +++++ + + +++ += ++
 = = =
 33 32 27

 ↓± 5 2=4 ±
C=100=1 ↓= =4 2=
 ++ 65
 ↓±
 ↓=
 2

T█████TITLAN
↓↓↓↓↓↓↓↓↓↓↓↓↓↓
13Ⅳ0II11I7ⅣⅣ
↓↓↓↓↓↓↓↓↓↓↓↓↓↓
I340III1I754
+++++++ + +++
 =
 29 PINTA NINA FLOWER
 ± SANTA MARIA ↓↓↓↓↓↓
 4I=2 ⇒ MAY FLOWER 7 7 0 3 3 9
 + + + + +
 =
 29
 ±
 2=4

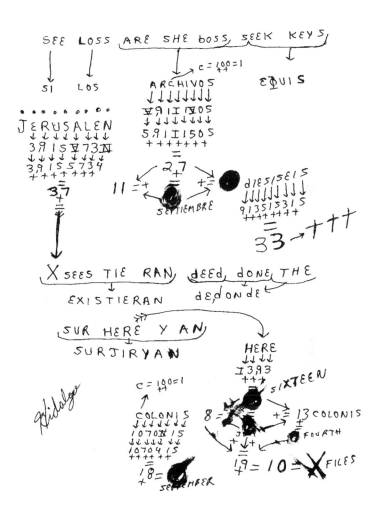

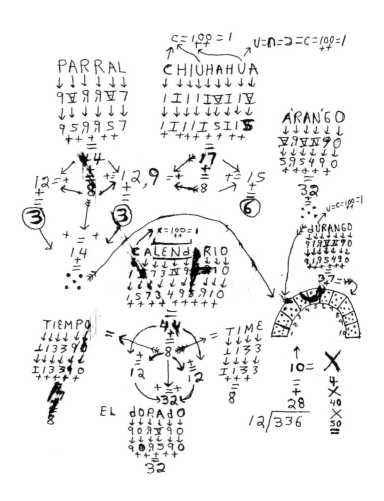

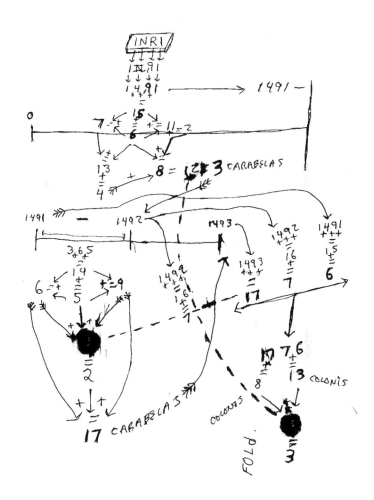

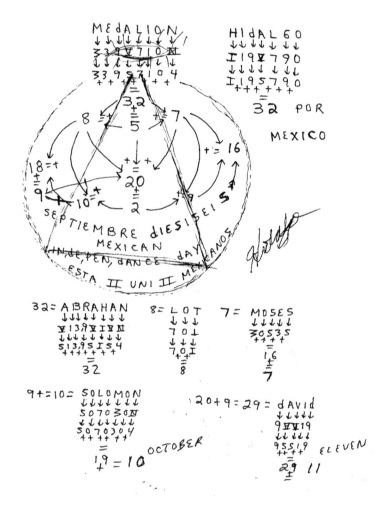

MEDALION
33971074
33957104
= 32

HIDALGO
I19X790
I195790
= 32 POR

MEXICO

3+2 = 5
8 = +
+ = 7
18 = +
+ = 16
+ = 20 +
9 = +
10 = +
2
+ = 9

SEPTIEMBRE DIESISEIS
MEXICAN
INDEPEN, DANCE DAY
ESTA II UNI II MEXICANOS

32 = ABRAHAN
X1397IIXN
513,95I54
= 32

8 = LOT
70I
7,0I
= 8

7 = MOSES
30535
= 16
= 7

9+=10= SOLOMON
5070305N
5070304
= 1,9 = 10

OCTOBER

20+9=29= dAVID
9XX19
9SS19
ELEVEN
= 2,9 11

AN CONVERTIDO LAS AMERICAS
EN NIDO DE ⇉

YOU HAVE TURN THE AMERICAS
IN TO A NEST OF SNAKES

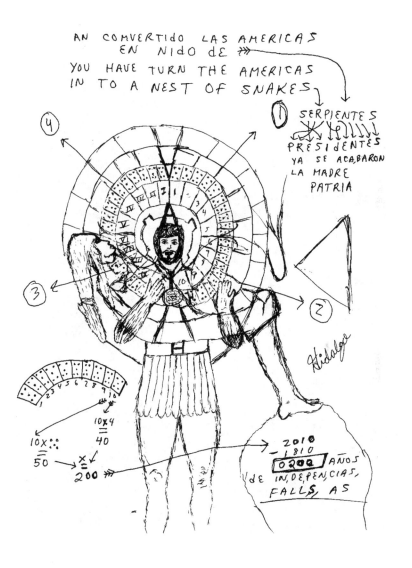

① SERPIENTES
PRESIDENTES
YA SE ACABARON
LA MADRE
PATRIA

Hidalgo

10x4 = 40

10x = 50

x = 200 ⇉

2010
−1810
0200 AÑOS
DE INDEPENCIAS,
FALLS, AS

202